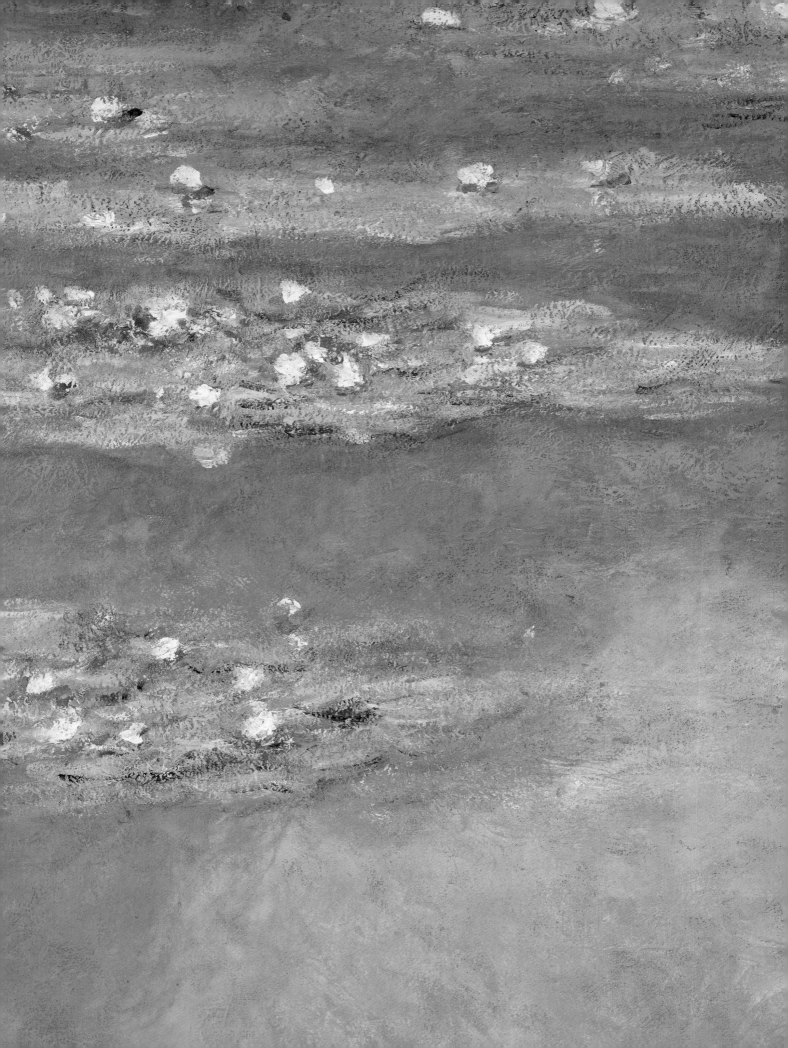

MONET

Impressionist Masterpieces from the
Museum of Fine Arts, Boston

Third edition, revised, 1991

Library of Congress Catalogue
Card No. 85-61990
ISBN 0-87846-256-2

Designed by Carl Zahn
Printed by Acme Printing Co.
Wilmington, Massachusetts

Cover and title page:
Details from
Claude Monet, **Water Lilies II,** 1907
Bequest of Alexander Cochrane
19.170

Catalogue entries by:

A.M. Alexandra Murphy
L.H.G. Lucretia H. Giese

Comments in italics are by
Elizabeth H. Jones

Introduction

Within weeks of the death of Claude Monet in 1926, the Museum of Fine Arts paid tribute to his memory with a major retrospective exhibition of paintings, the first and most important commemorative event held in the artist's honor anywhere in the world. That Boston should have edged out his native Paris in proclaiming Monet's genius was no surprise, however, for he had been the city's best-loved painter for more than thirty years. His first privately sponsored, noncommercial exhibition had been held in Boston, as early as 1892, at the St. Botolph Club; a spectacular loan show at Copley Hall in 1905 firmly established his preeminence among the city's art lovers; and the first museum-sponsored exhibition of his career opened at the Museum of Fine Arts in 1911.

All of this for an artist entirely unknown in Boston before 1889, the year a young Boston painter studying in Paris, Lilla Cabot Perry, prevailed upon a relative to acquire, sight unseen, one of Monet's views of Etretât. When Bostonians did discover his sparkling, brightly colored landscapes, however, they quickly welcomed him to their pantheon. For the 1892 exhibition, twenty-four pictures were brought together from the city's homes, and the organizers boasted that they could have borrowed twice as many – had gallery space permitted. After several more small shows of Monet's most recent work, the much grander Copley Hall exhibited some eighty pictures; and by the First World War, more than 120 paintings by Monet were hanging in Boston.

The enthusiasm for Impressionism in Boston was at one and the same time an extension of the preceding generation's world-famous passion for modern French painting and a conscious reaction against those older collectors' allegiance to the darker landscapes and work scenes of Jean-François Millet. For the most part, Monet's New England patrons were young and only modestly wealthy, and a surprising number were women. Few of them owned more than two or three of his paintings. Annette Perkins Rogers, who bought the first of the Museum's Monets to arrive in the city (no. 6), had studied painting with Millet's Boston disciple, William Morris Hunt; honeymooning in Paris, the Horatio Lambs

acquired their *Haystack in Winter* with their wedding money, at the urging of Horatio's sister, another Hunt pupil. One of the few older Bostonians willing to mix Millet and Monet in the same collection, Peter Chardon Brooks, seems to have been led to Impressionism by the advice of a younger artist, John Singer Sargent, who had studied Monet's technique at first hand. Only the three Edwardses, who purchased their Monets and Renoirs as a tribute to their mother (who had taught them to love painting with her old master and Barbizon pictures), consciously built a collection.

Fashionable, art-loving Bostonians were not alone, of course, in their admiration for this then-revolutionary artist; Americans in both New York and Chicago shared their appreciation of Monet's work, and even Paris was taking him quite seriously by 1890, after two and a-half decades of disdain. But Bostonians reveled in the primacy of their allegiance and the breadth of the Monet-admiration society in the city was unmatched. And in time, in exemplary Boston tradition, many of those collectors or their heirs would eventually remove the Monets from their private walls to present them to the public, making the Museum of Fine Arts holder of the greatest and largest collection of Monet's work outside Paris.

During the 1930s, the continuum of Monet exhibitions in Boston changed from loan shows of privately owned pictures, many quite fresh from the easel, to celebrations of the public collection of a new old master. Reinstallation of the Museum's paintings collection in 1935 was honored with a French paintings show that emphasized Monet; in 1956, a presentation of all the Museum's Monets accompanied by a group of Japanese fans and kimonos fêted the acquisition of *Camille Monet in Japanese Costume (La Japonaise);* and the 1962 gallery renovations were capped with the installation of a sweeping semi-circle of Monets atop the Evans Wing staircase – a presentation that remained a public favorite well into the 1970s. Most recently, in 1977, the exhibition "Monet Unveiled" commemorated nearly four years of careful conservation work that cleaned and restored the time-darkened paintings to nearly pristine condition.

As a result of the 1977 exhibition, three more Monet paintings were presented to the Museum by heirs of the original Boston purchasers, and the present book, prepared originally as the catalogue of that exhibition, is being re-issued now in a revised edition to keep pace with the still-growing collection. Editorial intervention in the original texts has been slight, but new color photography of all the paintings provides illustrations of a quality not available only eight years ago. The admiration felt by Boston's art lovers for Monet has never faltered; we hope *Monet in the Museum of Fine Arts, Boston* will simply spread the pleasure further.

ALEXANDRA R. MURPHY
Assistant Curator of European Paintings

Monet Observed

Claude Monet was gifted with an extraordinarily acute visual sensitivity. All his adult life he concentrated intensely and passionately on the development and refinement of his perceptions and their translation into paint as evocative and beautiful as he, with ever increasing refinement and skill, could achieve. He worked with tireless vigor and as his skills grew so did the intellectual demands he placed upon his skills. He was rarely satisfied.

He made the scenes and motifs that he chose immediately appealing to us – they are such beautiful paintings! It is only on close examination that we begin to appreciate the subtleties of his facture, the complex and delicate modulations of tones and of paint substance and brushwork that make him such a master.

These very refinements are the first qualities to be engulfed and lost in the all-encompassing tonality of aged yellow varnish and dark gray films of modern oily grime. Delicate lavenders and violets appear gray under such films, and subtly shifting blues become a more or less uniform green. The play of warm and cool tones is lost and the contrast of texture is deadened. The runnels made by brush bristles in a relatively smooth passage of paint are often filled in by a brush-coating of varnish (even of a colorless synthetic varnish too heavily applied), thus eradicating the sparkle of light over the tiny modulations of the painted surface. Even worse, clotted residues of old darkened varnish and grime left in the hollows of heavily impastoed paint appear like dark freckles, which impose their own random pattern on the strokes and stabs of paint that Monet had delicately adjusted in size and definition, in hue and value, to suggest the light falling on changing textures as they recede into the distance. These changes no longer work as he intended, and deep space becomes flattened into the plane of the canvas.

Few pictures are so disfigured, so altered from the artist's original intention, as are those of the impressionist school when covered with discolored varnish and grime. It is for this reason that we began a program of cleaning the Museum's splendid collection of paintings by Monet.

Before beginning any treatment it is customary to make a thorough examination of the work of art. From the examination of the thirty-seven oils in this exhibition, we have found certain patterns in Monet's choice of materials and in his working methods. Since the Museum's collection of paintings by Monet encompasses some forty-five of his sixty-eight years' work as a painter, these patterns are of some interest. It should be stated at the outset that the superlative condition of so many of the paintings, in this collection and elsewhere, testifies to Monet's care in the choice and use of materials and to his superb technical skill.

Materials

With the single exception of the earliest painting in the collection, *Road in the Forest with Woodgatherers*, of about 1863 (no. 1), which was painted on a rather primitive form of plywood, Monet used canvases of an extraordinarily fine weave. The range is from 10 to 34 threads per centimeter, the average about 20 threads per centimeter. Monet obviously preferred to build his textural effects with minimal interference from the grain of the canvas. Even after 1885, when be began to load his surfaces with paint so that the texture of the fabric is rarely seen, he continued to use these very fine canvases. He began his paintings by laying in tones in relatively thin paint, then built up the surface gradually. In some instances the first layer of paint was not completely covered, and became integral to the finished painting, so the texture of the canvas was still important to him. It is also possible that his preference may simply have sprung from a sensory reaction: he may not have liked the feeling of his brush moving across a coarser cloth. We know that he chose to wear fine linen.

All of the paintings in the Museum collection that can be dated before 1881 have colored primings, either tan, pinkish-gray, or off-white. In some of the earlier paintings, like the *Entrance to the Village of Vétheuil in Winter,* datable about 1879 (no. 11) Monet left the priming (in this case, tan) unpainted in areas where it is used as a middle value.

The paintings in this collection made after 1881 were all done on white primings. This shift in preference coincides with a new departure in his development as a painter. He began to use hues that are more intense and the values are often higher. Shadows are more luminous semitransparent dark greens, blues, and red-violets. Indeed, in the Museum's very earliest painting on a white priming, *Sea Coast at Trouville* (no. 13), Monet actually used the white ground as a tone in the sky, covering it incompletely with washes of blue, of more heavily bodied blue, violet and pink, then with final impastoed touches of pink and off-white.

As is often the case with artist's reports on their techniques, Monet's own list of the pigments that he used appears to be much oversimplified, perhaps because that was his palette at the time he wrote about it to his dealer, Georges Durand-Ruel. In a letter dated June 3, 1905, Monet itemized: "Blanc d'argent [lead white]; jaune cadmium [cadmium yellow]; vermilion; garance foncé [deep madder]; bleu de cobalt [cobalt blue]; vert emeraude [viridian green] et c'est tout."

Another list of Monet's colors given by Adolphe Tabarant in 1923 specifies three shades of cadmium yellow (light, dark and lemon) and adds to the list "ultramarine lemon yellow [strontium chromate yellow] and cobalt violet, light."

René Gimpel visited Monet at Giverny in the summer of 1926, shortly before Monet's death. In the large studio Gimpel saw a palette already set up, and reported that it presented "separate mounds of cobalt, of marine blue [probably ultramarine], of violet, of vermilion, of ochre, of orange, of dark green, of another green, not light however – just a few colors, and in the center of the palette mountains of white, snowy white."

Inge Fiedler of the Art Institute of Chicago, in a report on analyses of samples taken from paintings by Monet, has commented on the complexity of the mixture of pigments in them.

The Research Laboratory of the Museum of Fine Arts has verified Monet's use of cobalt violet in at least two paintings. We believe that Monet probably used whatever colorants that he found suitable for his particular motif, without confining himself to a palette set up in rigid accordance with a theory.

Technique

For the greater part of his working life, Monet preferred to use bodied paint, i.e., paint in which the content of oil is low. (It is significant that when he made quick sketches he chose the medium of pastels, rather than watercolor [nos. 3 and 4]).

Monet located the elements of his composition on the bare canvas with outlines in light blue paint – a simple brush drawing. These lines usually disappeared as he worked, but they can be seen underlying their later reinforcement in darker blue paint in the church tower and in the distant buildings on the right in *Entrance to the Village of Vétheuil in Winter* (no. 11). After this preliminary step, Monet usually began with a fairly flowing paint that spread easily and allowed him to set the tonality of the picture quickly, but that had enough substance so the bristles of the brush left runnels. Dark areas of foliage might be underpainted more thinly, to be worked up later in more bodied paint. Monet adjusted the quality of his paint to suit the texture of the substance that he was portraying. A sheet of calm water, for example, might be treated with rich paint, blended smoothly when wet by parallel strokes, while broken water is represented by many small, heavily bodied touches, leaving a rough surface (see no. 27).

Many of the later pictures in this collection have layers of heavily bodied paint so stiff that it has been suggested that Monet removed part of the oil found in paint as it is normally supplied by the colormaker. It is a tribute to his self-control as a craftsman that these complicated layerings of paint have resulted in so few technical problems and have held up so well. Monet had patience to wait until each layer dried, unless he wished to blend colors on the canvas instead of on the palette. Only in certain dark passages in the Creuse series (now. 25, 26, and 27) do we find the phenomenon termed "rip crackle," which forms when a faster-drying layer is painted over one that is still not set.

Artists who apply paint in layers often add the final adjustment of tones with a "glaze," a film made semitransparent by the addition of extra oil or even of an oil varnish. Not so Monet. He often added a final unify-ing layer, but these films are transparent because they are laid on so thinly, not because they are richer in oil. Among these pictues it is only in *Camille Monet and a Child in a Garden,* dated 1875 (no. 8), particularly in the flesh tones, that we find paint that is transparent because of its high oil content. This choice may have been influenced by Renoir, who preferred richer, more flowing and transparent paint. Renoir and Monet often painted side by side at this time.

In the 1880s Monet quite consciously developed a repertory of brushstrokes to capture quickly the aspects of his subject and the atmosphere and mood that he wished to portray. Repetition brought a mastery in the movement of his brush. The direction that his hand took, the length of the stroke, the amount of pressure applied, came under sure control.

At this period, Monet often laid in his skies with a fairly wide brush (2 or 3 centimeters) in smoothly flowing paint to form diagonal strokes in a looping, zigzag pattern. These strokes can most easily be observed where the sky was later reworked only slightly, as in *Meadow at Giverny in Autumn* (no. 19) for example, or as a final layer over horizontal strokes at the left in the sky of *Stone Pine at Antibes* (no. 21). He commonly used a long dragged stroke of more heavily bodied paint, often blended into parallel strokes of the same nature. Such strokes are used vertically in the grasses at the right of *Poppy Field in a Hollow near Giverny* (no. 18) or horizontally in the distant water in *Cap Martin, near Menton* (no. 17) and in *Road in a Hollow* (no. 16).

He employed a series of straight strokes like dashes, of varying length and hue, to portray rippling water, as in the early *Ships in a Harbor* (no. 5). If the water was rougher, the strokes might curve or ripple as the water itself did. So vividly do these broken strokes capture the rushing water in the *Ravine of the Creuse III* (no. 27) that we can almost hear it.

There appears repeatedly a "skip" or "skim" stroke in thickly bodied paint that, either because of the rough texture of the paint underneath, or because of the calculated vibration of his brush, left a deposit of paint, lifted, then left another broken swath of paint again as the brush swept across the canvas. This can be seen in its most delicate form in the white highlight on the still water at the left in the *Branch of the Seine near Giverny II* (no. 34), where a tiny brush left a threadlike trace that helps to establish the plane of the water. The skip stroke is used more boldly in the river of *Flower Beds at Vétheuil* (no. 14). Since these skip strokes left partly exposed the tone underneath, often one of a different hue, they set up a vibration of color. In *Meadow with Haystacks near Giverny* (no. 20) the skip strokes in yellow, added as the final touches on top of many other hues, suggest perfectly the flicker of sunlight coming through the screen of trees at the right.

A single twisted stab of loaded paint, sometimes of two hues barely mixed on the palette, quickly forms one of the many blossoms in the flower bed behind Madame Monet in *Camille Monet and a Child in a Garden* (no. 8). Nowhere is the control of a series of stabbed touches more evident than in the flowers in *Poppy Field in a Hollow near Giverny* (no. 18). Over a tone of yellow-green Monet placed a number of discrete daubs in the foreground, in vermillion with accents of crimson. As the field recedes into the distance the touches become paler and more transparent, have softer edges, and blur into one another. At first glance the field seems uniform, but the adjustment of shape, texture, and hue makes the near or distant poppies take their proper places.

Monet felt no need to draw in outline a complicated shape; five touches of the brush, five strokes of different angles and shapes, define a distant pink sailboat, scudding before the wind in *Cap d'Antibes: Mistral* (no. 24 and cover detail). The wind sped Monet's brush along, too: the tops of the mountains were formed with quick hooked strokes of lightly mixed pink and white. On the tree in the foreground small curling flicks of light yellow and pink lie on top of darker tones, suggesting the movement of leaves tossed in the wind.

If the motif required, Monet would build up an area with countless strokes of a delicate brush. In the foliage in the foreground of

the *Fisherman's Cottage on the Cliffs at Varengeville* (no. 15), he laid down a mesh of fine crossing diagonal strokes, adding final accents with a tiny loaded brush.

Monet tempered his treatment to the mood of the day. He left the *Cliffs of Petites Dalles* (no. 12) in almost rough sketch form, content that the unmodified brushwork matched the stormy day. In contrast, he used layer on layer of paint applied in gentle sinuous strokes to catch the quiet tempo of the hazy, dreamy autumn air of the *Meadow at Giverny in Autumn* (no. 19).

By the end of the 1880s, his craft completely mastered, he began to focus his attention with greater concentration on the things that he found harder to do, the capture of specific moments of light and enveloping atmosphere in the series paintings. Differences in texture come through only as they alter the quality of light.

The complicated shifting planes of the stone surfaces of the cathedral in Rouen evoked a new treatment. In nos. 31 and 32 we can find very few passages in the façades where the paint retains evidence of its application by a stroke of the brush. Whatever the means used to build up the many thick layers of paint, the final surface is almost everywhere pitted, as if Monet had stabbed the paint on with a stiff brush held at right angles to the canvas.

This same stabbing technique is used for the water in the two versions of *Waterlilies* (nos. 37 and 38), where it suggests a slight riffling of the surface of the stream. In certain passages a final smooth tone fills in the pits in the paint, as if a local current had smoothed out the riffles in the water.

Monet's visit to Venice in 1908 lifted his spirits. He was exhilarated by this magical city that seemed to float on water, by its color and atmosphere. *Grand Canal, Venice* (no. 39) reflects his enjoyment; it is painted with more freedom and ease, as if he felt released from the necessity of the fierce concentration that he put into the earlier series paintings. His concern for the textural variety of brushwork in the paintings done in the 1880s is now eclipsed by an interest in capturing an effect of opalescent atmosphere.

Most paintings of some age have been given a coating of varnish. This serves to protect the surface from minor abrasions and accretions and to even out the reflection of light. However, after examining the Monets before treatment began, we found that two paintings, *Field of Poppies near Giverny* (no. 28) and *Charing Cross Bridge* (no. 36), had never been varnished. Cleaning in this case simply involved the removal of grime from the surface.

While removing discolored coatings from the other paintings, we found that several had grime films under the varnish, indicating a lapse of time before they were coated. Without documentary records it is impossible to determine when varnish was applied, but on the tenuous evidence of these underlying grime films, we are beginning to wonder whether Monet himself actually varnished his paintings. He has been quoted as saying that the dealers used to varnish the Impressionists' pictures with bitumen to blacken them because they considered them too light.

Museum records, although rather imprecise in earlier times, show that many of the paintings in this collection were cleaned once, or even twice, after coming here. Until about the last decade, they were then revarnished with natural resin coatings, either dammar or mastic, which unfortunately deteriorate as they age. They quickly yellow, then become darker. They may develop fine cracks, or bloom (forming a whitish iridescence like that made by a wet glass on a varnished tabletop).

After the recent cleanings the paintings were spray-coated with a synthetic resin, polyvinyl acetate. This substance has proved to have a remarkable stability: samples dated in the 1930s in the Conservation Laboratory of the Fogg Art Museum are still colorless, still uncracked, still without bloom, and have remained readily soluble in mild organic solvents. We can anticipate that from now on these paintings will require only superficial cleaning to remove grime.

ELIZABETH H. JONES
Conservator of Paintings

Rewald, John. *The History of Impressionism,* 4th rev. ed., New York, 1973.
The standard documentary history of Impressionism, tracing the founding of the Impressionist group, their exhibitions and development, and the beginning of its disintegration under the pressure of early post-Impressionist movements. Not as complete on the later years of the artists, which are covered elsewhere by Rewald. Many reproductions.

Seitz, William C. *Claude Monet.* New York, 1960.
One of the Abrams series of large books with good color plates, Excellent short texts, black and white illustrations of paintings and drawings, photographs of several of the motifs Monet painted.

House, John. *Monet.*
Oxford, 1981
Short essay with thoughtful commentaries on forty-eight color reproductions.

Gordon, Robert, and Forge, Andrew. *Monet.* New York, 1983.
Profusely illustrated biography drawing frequently on Monet's very enlightening letters as well as contemporary photographs.

Cooper, Douglas, and Richardson, John. *Claude Monet.* Catalogue of an exhibition at the Edinburgh Festival and Tate Gallery, London, 1957.
Cooper provides a very good short essay on Monet's development, and Richardson a particularly complete chronology of the artist's career.

Perry, Lilla Cabot. "Reminiscences of Claude Monet from 1889 to 1909," *American Magazine of Art,* March 1927, pp. 119–125.
The personal remembrances of a Boston painter who lived and worked near Monet in Giverny for many years; also the source of much of our general knowledge on Monet's attitude toward painting and working methods. Very readable.

Seitz, William C. *Claude Monet – Seasons and Moments,* catalogue of an exhibition at the Museum of Modern Art, New York, 1960.
A good essay that traces Monet's changing attitude toward nature. Includes a number of important quotes from Monet and several color plates.

Biographical Summary

Hamilton, George Heard. *Claude Monet's Paintings of Rouen Cathedral.* Williamstown, 1969.
Lecture republished as a short essay. Provides a good general discussion and includes reproductions of prints and photographs that may have influenced Monet's choice of viewpoint.

Champa, Kermit. *Studies in Early Impressionism.* New Haven, 1973.
Specialized essays on the early work of the Impressionists, particularly helpful in sorting out their mutual influences.

Tucker, Paul Hayes. *Monet at Argenteuil.* New Haven, 1982.
Considers Monet's landscapes painted in and around Argenteuil during 1870s from the standpoint of the town's changing character as Paris and industrialization intrude.

Wildenstein, Daniel. *Claude Monet, Biographie et catalogue raisonné,* vols. 1-4. Geneva, 1974-1985.
Lengthy biography and complete catalogue of the artist's paintings. All the known paintings are illustrated, and the author reproduces a large number of Monet's letters. Standard biography and catalogue. (In French.)

1840
Claude Monet born in Paris, November 14.

1845–1858
Family moves to Le Havre, where Monet meets Boudin and becomes his pupil.

1859–1862
Establishes himself in Paris, studies at Académie Suisse, meets Pissarro; later studies at Académie Gleyre with Bazille, Renoir, and Sisley.

1863
With new friends paints out of doors in the Forest of Fontainebleau.

1864
Meets Courbet in Paris; paints at Honfleur.

1865
Beginning of relationship with Camille Doncieux, whom he marries in 1870; Cézanne visits Bazille and Monet in Paris; two paintings accepted and exhibited at the Salon; paints again on the coast with Daubigny and Courbet.

1866
Introduced to Manet; exhibits again at the Salon; paints near Paris and Le Havre.

1867
Son Jean born in Paris.

1869
Paints with Renoir at Chatou and Bougival.

1870
Escapes at outbreak of Franco-Prussian War to London, where he paints and is introduced to the dealer Durand-Ruel.

1871
Following short trip to Holland, settles in Argenteuil.

1874
First Impressionist exhibition in Paris; Renoir and Manet paint with Monet at Argenteuil.

1876
Works on Gare Saint-Lazare paintings in Paris.

1878
Second son, Michel, born; moves to Vétheuil.

1879
Camille Monet dies.

1880
Exhibits for last time at the Salon; resumes regular painting trips to the Normandy coast.

1883
Moves to Giverny.

1884
Travels to the Mediterranean coast for a few months.

1886
Paints at Giverny; last Impressionist exhibition, Monet having participated in five out of eight.

1888
Works at Antibes.

1889
Begins paintings of the Creuse river.

1890
Poplars on the Epte and Haystack series (both continued 1891); begins to construct water garden at Giverny.

1892
Begins Rouen Cathedral series (continued 1894); marries Mrs. Ernest Hoschedé.

1895
Excursion to Norway.

1896–1897
Works on Mornings on the Seine series.

1899
Involved with water garden, resulting in various series that are continued for the rest of his life; in London in the fall and two successive winters working on Thames series (continued 1904).

1908
Illness and problems with vision; visits Venice, returning next year, working on Venetian paintings (continued 1912).

1911
Mme. Monet dies.

1916
Begins large water lily decorations later installed at the Orangerie, Paris.

1922
Double cataracts prevent work.

1923
Operation partially restores sight.

1926
Dies at Giverny, December 6.

1
Road in the Forest with Woodgatherers
Signed, about 1863
Oil on panel
23½ x 35½ in. (59.7 x 90.2 cm.)
Henry H. and Zoe Oliver Sherman Fund
1974.325

Road in the Forest with Woodgatherers reflects Monet's earliest forays into the Fontainebleau Forest outside Paris in 1863, and marks one of his first attempts to establish a personal approach to painting directly from nature. Although he clung to the rather dark color scheme favored by the older group of artists still working in Fontainebleau, the so-called Barbizon School, he eliminated here much of the accumulation of detail and texture that characterized their work as well as his own earlier paintings. The scene is simplified into broad areas of light and shade, with attention focused on the last traces of sunlight glancing across the edge of a forest clearing. Monet used the few strongly lighted tree trunks and the patch of sun-brightened field to draw the viewer away from the shadowy, uncertain center that holds the converging lines of footpath and trees in check. With the simplified composition and muted detail, he could experiment with a soft, broad brushstroke, shaping individual trees only where the sunlight catches them.

At the time Monet worked in Fontainebleau, he was still ostensibly studying in the studio of a prominent Paris painter, Charles Gleyre, but his attendance in classes that emphasized figure drawing and conventional art principles seems to have been a sop to his father's continuing opposition to Monet's career as a painter. He spent most of his time painting out of doors, taking his lessons from nature directly, or from those few landscape artists whose work he had come to admire in Paris.

A.M.

Examination by infra-red vidicom and by radiography have established the presence of another painting underneath the present design. These techniques have revealed a massive single tree just left of the center. Its shape seems very similar to the tree in The Bodmer Oak *(Metropolitan Museum of Art, New York), a famous tree in Fontainebleau. Its upper branches and leaves extend under much of the present sky. Another group of trees appears at the right, again extending into the present sky.*

In December 1866, Monet wrote to Frédéric Bazille in Paris, asking him to send to him in Le Havre some of his paintings that he could "scrape down and reuse." As we can find, in this case, no evidence of an attempt to scrape down or efface the first picture, it is likely that the young Monet did not realize, at the time he reused this panel, that oil paint becomes more transparent with age. The second painting probably covered the first one perfectly adequately for some time after Monet had finished it. Now, however, a single stroke of one tone of the new sky, for example, appears different in hue and value as it passes over the old sky, then over the dark leaves of the tree beneath and on to cover the old sky. This creates a certain confusion in our viewing. Some discreet inpainting has been added to raise the value of the darkest spots to the level of the final tone.

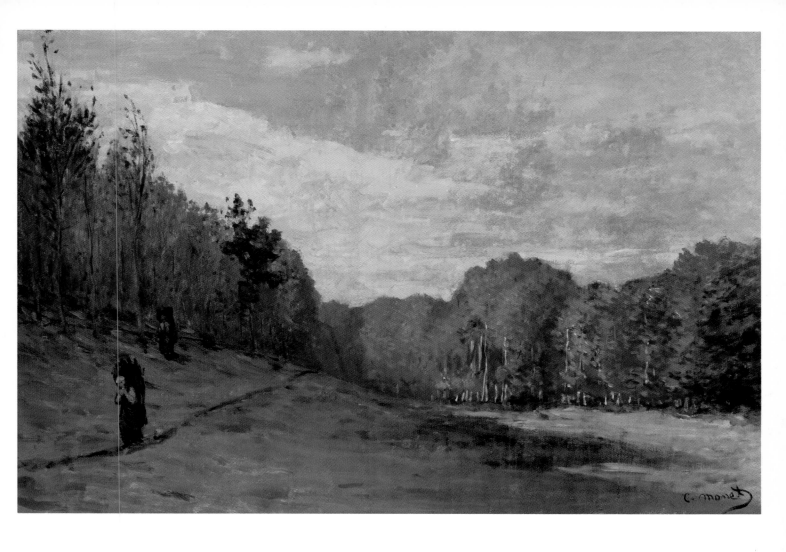

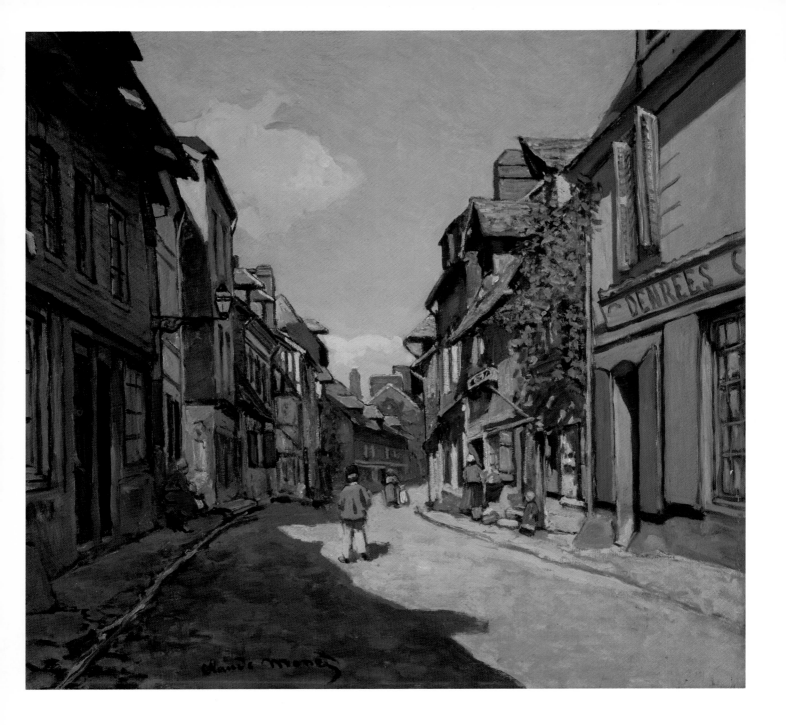

2
Rue de la Bavolle, Honfleur
Signed, about 1864
Oil on canvas
22 x 24 in. (55.9 x 61 cm.)
Bequest of John T. Spaulding
48.580

Monet grew up in Le Havre, a prosperous sea-port on the Normandy coast, and his first exhib-ited paintings are of the long, rocky shore above the city and of the nearby villages. For many years after his move to Paris in 1862 he regularly returned to Normandy to paint; *Rue de la Bavolle, Honfleur* (across the Seine estuary from Le Havre) was painted during such a summer visit in 1864. Despite its very different subject, it repeats the basic composition of *Road in the Forest with Woodgatherers* (no.I), with strongly contrasted areas of light and shade, open fore-

ground, and interlocking diagonals. Monet had explored the same composition in a number of other landscapes — a process of repetition and reworking that he would follow for years and that would later lead naturally to the series of paint-ings of a single motif — and he had finally mas-tered the deceptively simple arrangement of forms. The street winds steeply back into the picture, slowed by the figures along the way, and the demarcation line between shadow and bright sunlight, softened and shifted to one side in the earlier work, now runs a bold and ragged course up the middle of the painting.

Monet came into his own as a colorist in the Normandy paintings of 1864 and 1865. He no longer relied on the more subdued color schemes of earlier landscape painters, but drew his own rich range of yellows, browns, and grays from the actual hues of the village buildings. His handling of paint shows his increasing sureness,

from the broad loose strokes of the dusty road-way to the thickly painted ivy leaves that seem to float free of the wall from which they hang.

The technical competence Monet had acquired in Paris, and the pleasing aspect of the land-scapes he knew well and loved, brought him praise at the Paris Salon of 1865. For a while he might have seemed destined for a convention-ally successful career.
A.M.

While learning his craft, Monet worked in the tra-ditional way. The shapes of the buildings are out-lined in dark paint, smoothly blended; rough cob-blestones and highlights are rendered in a more bodied paint with a small brush. The gray shad-ows barely shift in hue to recognize the local color of the area on which they fall. Figures are depicted in two values, light and dark, with little evidence of a middle value.

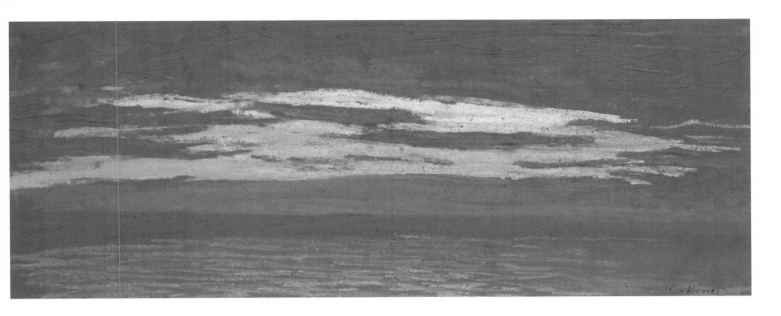

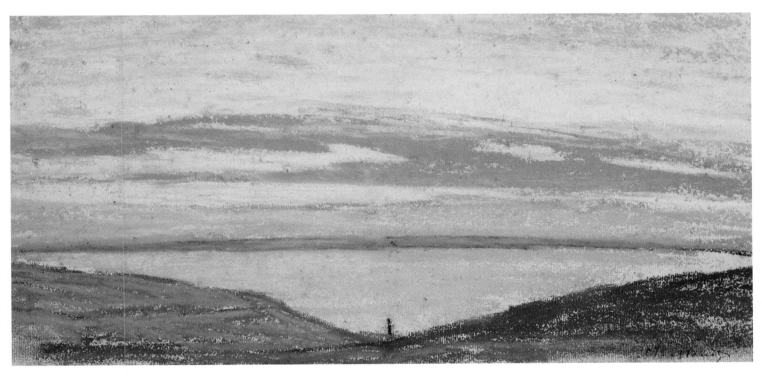

3
View of the Sea at Sunset
Signed, about 1874
Pastel on paper
10 x 20 in. (25.4 x 50.8 cm.)
Bequest of William P. Blake in memory of his
sister, Anne Dehon Blake
22.604

4
Broad Landscape
Signed, about 1874
Pastel on paper
10¾ x 18 in. (27.3 x 45.7 cm.)
Bequest of William P. Blake in memory of his
sister, Anne Dehon Blake
22.605

Seven of Monet's twelve entries in the first Impressionist exhibition in 1874 were pastels, suggesting that he regarded these works as important in his early years, even though they were carefully labeled as studies or sketches. *View of the Sea at Sunset* strongly recalls the pastels of Boudin, Monet's first master, who accumulated several hundred carefully annotated pastel studies, recording the look of sea and sky at every hour and season. It is unclear whether Monet viewed the *Sunset* as simply an *aide mémoire,* as Boudin intended, or as an independent work of art. It captures the last pink-orange streaks of sunlight across a lavender sky, after the sun has already sunk from view. Dusk softens the horizon until it is almost lost in the sky, blurring the distinction between the sunset and its reflection in the sea.

Much of the sky in *View of the Sea at Sunset* has been worked with brush and water, as well as simple pastel chalk, reflecting the innovations in

technique and intention that the Impressionists were bringing to the pastel medium.

In *Broad Landscape,* Monet shifted from the study of light and clouds that characterized *Sunset* to the resolution of a difficult compositional problem. While his attention to the sky and its wealth of colors remains strong, here he seemed to be searching for a landscape format that would allow him to devote nearly two-thirds of a picture to sky, yet maintain a measure of interest in the less immediately dramatic foreground. Both the sloping fields that begin below the horizon on either edge and the ambiguous figure silhouetted against the sea serve to pull the viewer's attention back from the bright sun breaking through the clouds, and to create an intriguing ambiguity of scale and distance.
A.M.

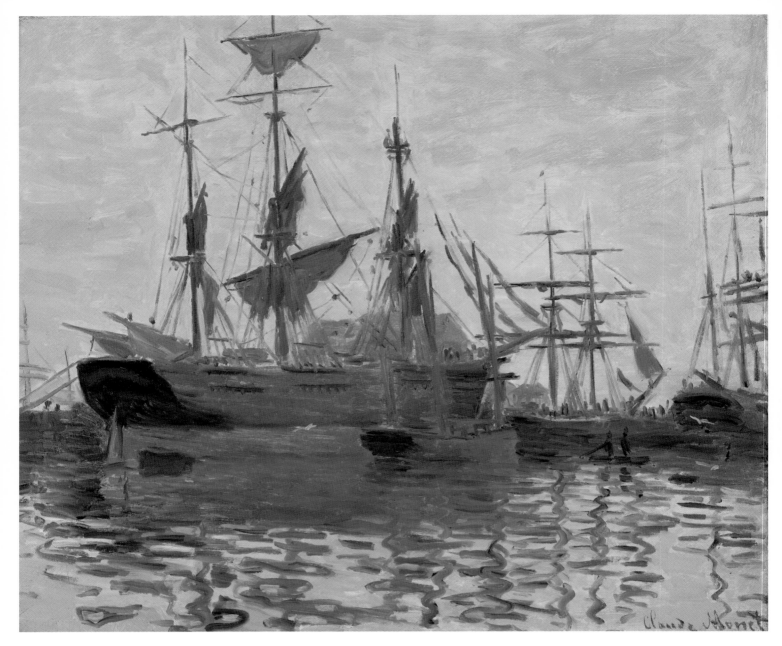

5
Ships in a Harbor
Signed, about 1873
Oil on canvas
19⅝ x 23¾ in. (49.8 x 60.3 cm.)
Ross Collection. Gift of Denman W. Ross
06.117

For this harbor scene of the early 1870s Monet turned from the bright effects of sunlight he had explored earlier to the challenge of a heavily overcast sky that dims and grays even the strongest local colors. Monet found a wide range of greens, browns, and blues woven throughout the pervasive blue-pink mist, and he seems to have been particularly attracted to the subtle shifts in those colors as they are reflected in the colorless sea below.

This picture marks another important development in Monet's interests, for as he became increasingly adept at rendering the variety of color problems that attracted him, he gave more and more attention to creating a language of brushwork that could accommodate the fleeting visual effects he pursued. The bold, zigzagging patterns of strokes that capture the broken reflections of the masts are echoed in the broader, although less assertive, patterns of the drifting sky. Figures and birds are reduced to the simplest notations necessary to convey their identity. Occasionally, color seems to be used independently of any descriptive purpose, as in the intense

blue stroke on the deck of the largest ship. Monet apparently discovered the importance of Courbet's famous advice to paint what one saw, quickly, before one knew what it was and lost its effect.
A.M.

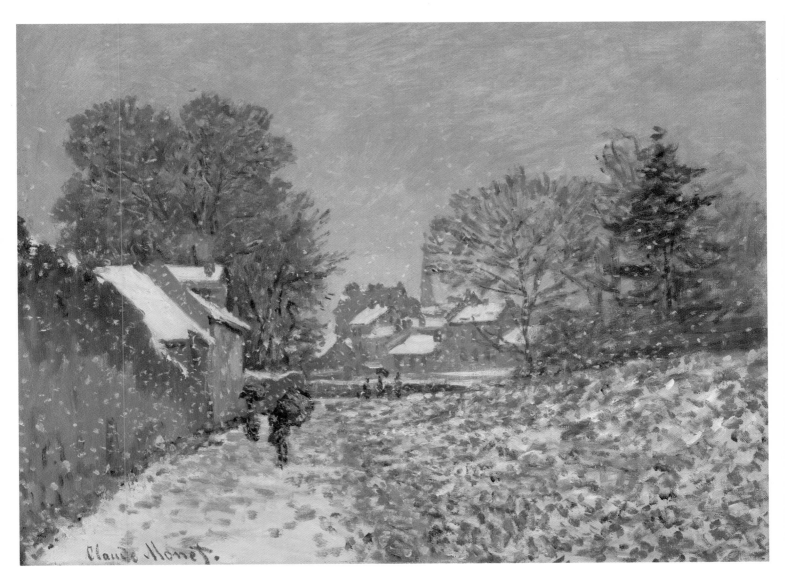

6
Snow at Argenteuil
Signed, about 1874
Oil on canvas
21⅝ x 29 in. (54.9 x 73.7 cm.)
Bequest of Anna Perkins Rogers
21.1329

The same sensitivity that could reveal the wide range of colors underlying the pervasive gray of a mist-shrouded harbor (no. 5) directed Monet's attention to other overcast conditions. The heavy leaden skies of a snowstorm provide the unifying tone in *Snow at Argenteuil* but, as in the *Ships in a Harbor,* the initial effect is deceptive. Looking carefully at the blue smoke, brown trees, patches of green grass, and the small black and red figures, it becomes evident that there is very little true gray in the painting.

The format of *Snow at Argenteuil* is one Monet used again and again, even when painting his garden some forty years later: a distant view of a town or city (or garden bridge), an intermediary screen of trees or buildings, and figures, trees, or buildings along a path or roadway that opens into the viewer's own space. The great effect of depth that Monet created in this way allowed him to manipulate the color-absorbing effects of atmosphere in a tonal picture like *Snow at Argenteuil,* and it also gave him wide scope for his vast repertoire of descriptive brushstrokes. The thick, fluid white paint has all the weight of damp, heavy snow accumulating on rooftops, while the

free and nearly formless green, brown, and white strokes strewn across the low hillside duly record random patches of fallen leaves and mud that lose their identity under snow. Most effective are the bigger-than-life snowflakes, which seem almost to float in front of the painting, a screen between the viewer and Argenteuil.

Monet had moved late in 1871 from Paris to Argenteuil, a small village several miles northwest of Paris. In letters to Renoir and to Durand-Ruel, who had recently become his dealer and given him a temporary measure of financial security after years of extraordinary poverty, Monet stressed his great need to work alone, away from the distractions of Paris and other painters, in order to meet nature as directly as possible.
A.M.

The count of ten threads per centimeter makes this the coarsest fabric of all the canvases used by Monet in this collection. The priming, a warm gray in color, is left unpainted in many areas. Even the sky is often very thinly painted because the priming was so close in value to the cooler leaden gray of the paint.

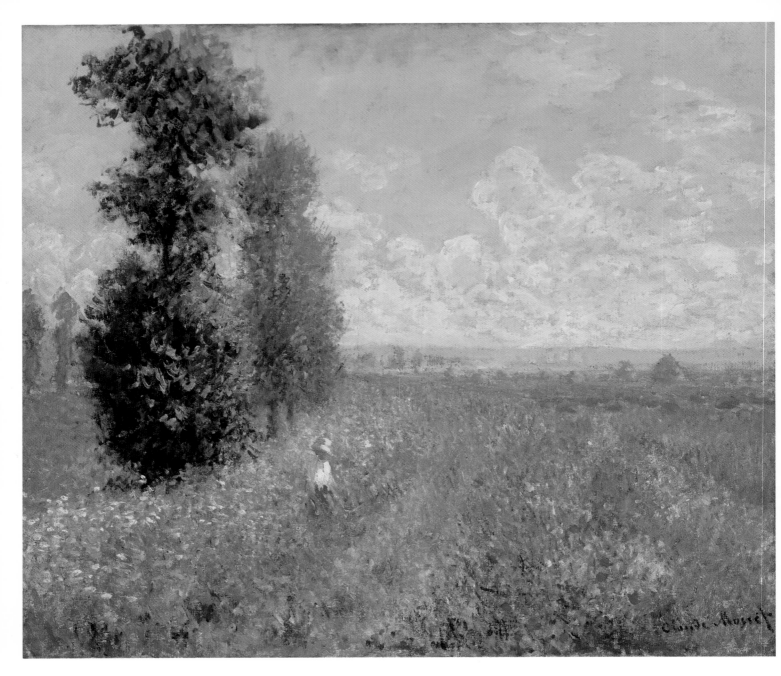

7
Poplars
Signed, about 1875
Oil on canvas
21½ x 25¾ in. (54.6 x 65.4 cm.)
Bequest of David P. Kimball in memory of his
wife, Clara Bertram Kimball
23.505

Poplars has characteristics that for many represent the quintessence of Impressionism. Bright, clear sunlight pervades the painting, fluffy white clouds pile up across a deep blue sky, light flashes off the edges of fluttering poplar leaves, and a whole prism of colors — even a few of the sharp vermilion notes that made poppies a kind of trademark for Monet in the 1870s and 1880s — flicker through the wildflowers and grasses of a broad meadow. Several blue-pink haystacks are visible in the distance.

In 1875 Monet's Impressionism was indeed at its height. His eye could dissolve a complex landscape into an extraordinary interplay of colors and values the casual viewer might never see. His determination to record the most transitory light effects and to fix for a moment the movement of the sea, the wind in the grass, or the drift of snowflakes, had driven him to develop an entirely new vocabulary of brushstrokes, and to give to the shape and density of individual brushstrokes a descriptive importance they had seldom before carried. And his art had declared

forcefully that the simplest landscapes, the commonest views of villages or fields, and the most unpromising weather conditions had a visual richness worth his repeated exploration and the viewer's most serious contemplation.
A.M.

By 1875 Monet had perfected a technique for suggesting space. The foreground has sharp contrasts of value and hue, in bodied paint. As the space recedes, the hues become cooler and less intense, the values become higher and there is little impasto. In the distance, edges between objects are blurred, the paint is more liquid, and it is possible to see how the brush blended one tone into another while they were still wet.

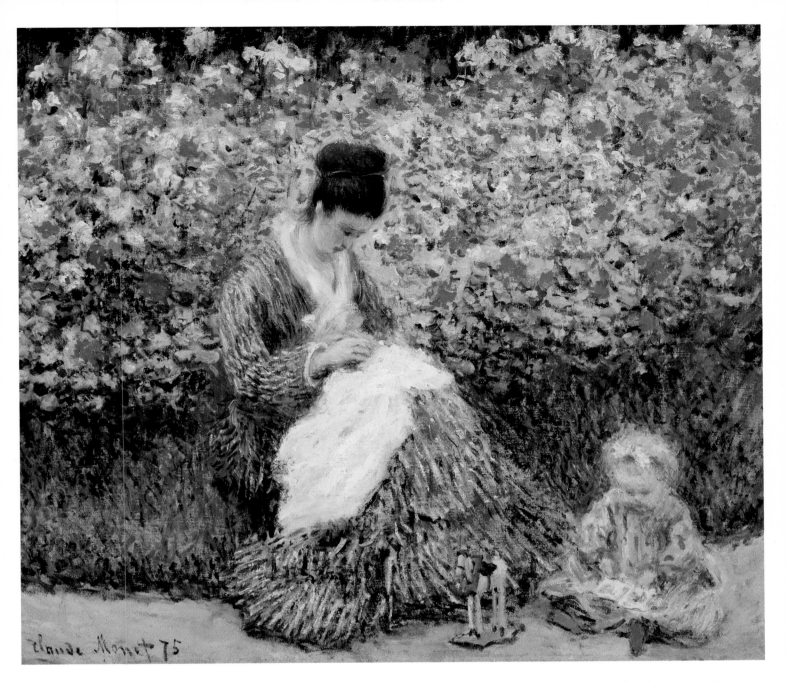

8
Camille Monet and a Child in a Garden
Signed and dated 1875
Oil on canvas
21⅞ x 25¾ in. (55.6 x 65.4 cm.)
Anonymous Gift in memory of
Mr. and Mrs. Edwin S. Webster
1976.833

Camille Monet and a Child in a Garden dates from the midpoint of Monet's Argenteuil period. It shows his first wife sewing in their garden accompanied by a small child (who is too young to be their son Jean). The figures are intended less as portraits than as part of a landscape seen in shimmering light and enveloped by the clear air, made palpable by Monet's quick strokes of opaque bright color. He made the figures appear to share the same spatial plane as the bed of flowers behind them by using consistent paint textures, putting warm colors behind cool, and simplifying the pictorial elements to triangles and rectangles. It appears that Monet was making an effort to paint what he actually observed, rather than to paint in a manner dictated by academic convention.

Although his portrait of *Camille* (in the Kunsthalle, Bremen) was shown in the Salon of 1866, Monet's first attempt to paint full-scale figures in the open, the monumental *Women in a Garden* (in the Louvre) was rejected the following year. Discouraged by the rejection and by the prob-

lems with works of that size, he began to paint material readily available to him after his move to Argenteuil in 1871, working directly out-of-doors, diminishing the size of the figures in the landscape, and using more intense color.

In these years both Renoir and Manet also painted Monet's family and gardens at Argenteuil, where Sisley and Caillebotte were at work as well. This interaction resulted for a time in a more unified style among the Impressionists. Renoir's influence may, in fact, partially account for the increased fragmentation of color and the frequent use of figures in Monet's Argenteuil paintings. They are distinguished by a tenderness and joyousness unmarred by Monet's financial and artistic difficulties.
L.H.G.

The flesh tones are in thin transparent paint that barely stains the gray priming; they were worked up with the most delicate accents of a tiny brush, a technique close to that of Renoir, who often worked side by side with Monet at this period.

9
La Japonaise
Signed and dated 1876
Oil on canvas
91 x 56 in. (231 x 142 cm.)
1951 Purchase Fund
56.147

In 1876, for the second Impressionist exhibition, Monet suddenly and unexpectedly presented the very un-Impressionist *La Japonaise*. Not since his popular success with *Camille* in 1866 had he exhibited a major figure painting. Although he received several portrait commissions in the 1860s and he undertook two immense outdoor figure compositions (only one of which was completed), by the time of the first Impressionist exhibition in 1874 he had effectively abandoned people in favor of landscape pure and simple. Only occasionally were figures included as additional elements of form.

Here Monet may have wished to repeat his earlier success—like *Camille,* this is a life-size, full-length portrait of his wife in elaborate costume, a *tour de force* of texture and color; or perhaps, as he later implied, the picture was actually meant to mock the exaggerated importance attached to figure painting at a time when landscape was still considered a minor genre. Predictably, the picture was generally well received and sold for a considerable sum.

Although the painting is often seen as Monet's tribute to the Japanese prints that were so influential for the Impressionists, it is a painting more Japanese in decor than in feeling, too contrived in pose and costume to convey the surprising spontaneity and subtlety of composition that were the principal appeal of Japanese prints for Monet and his friends. Rather, the picture is a standard costume portrait, notable for the glorious color of the kimono and for Monet's clever arrangement of the garment, which gives the lifelike samurai an animation that seems to lift him off the gown.
A.M.

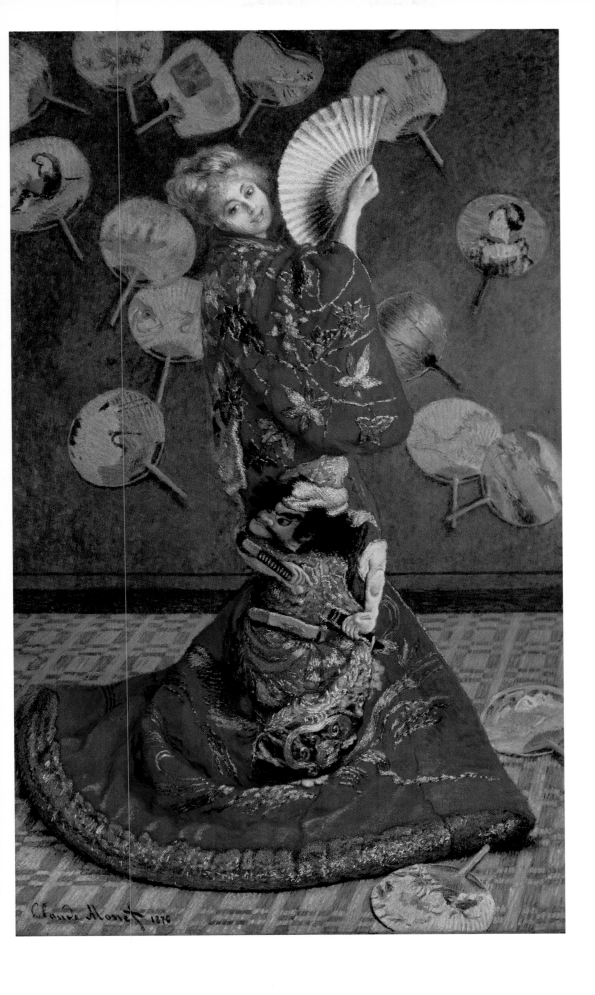

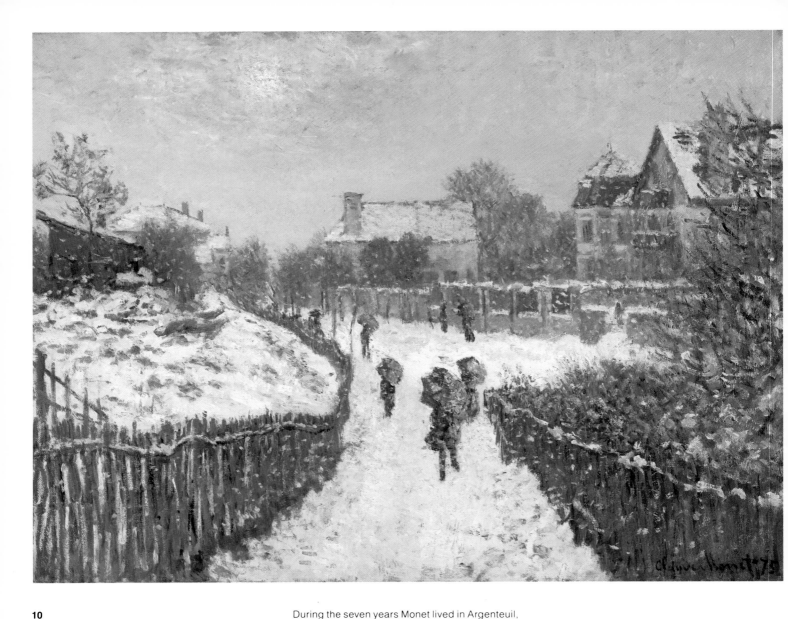

10
Boulevard St.-Denis, Argenteuil, in Winter
Signed and dated 1875
Oil on canvas
24 x 32⅛ in (60.9 x 81.5 cm.)
Gift of Richard Saltonstall
1978.633

During the seven years Monet lived in Argenteuil, the small town's transition from rural village to industrial suburb was reflected in his own increasing interest in town and city landscape. For an earlier winter scene (no. 6), Monet had selected a site that masked the town with a line of trees and emphasized the grassy hillside spreading off to the right, an approach to Argenteuil that stressed its rural locale. For *Boulevard St.-Denis*, however, Monet set his easel at the very edge of the railway tracks, looking down a new embankment, with its emphatic temporary fencing, toward his own recently built house. Instead of characterizing Argenteuil with more enduring attributes – the old town massed beneath the seventeenth-century church spire, surrounded by countryside, he chose to preserve the landmarks of urban change and expansion, construction fencing and isolated new houses along unpaved streets. This was not critical realism, however, but another manifestation of Monet's conviction that the beauty of a painting lay in the use the artist made of his subject, not in the subject itself. Once again a cloudy, wet day prompted him to explore unusual color effects, as he manipulated the whites and grays of soggy snow and overcast skies to tame and unify the assertive colors of an asparagus-green fence and a turquoise-trimmed pink house, and even to soften the brilliant radiance of the sun.
A.M.

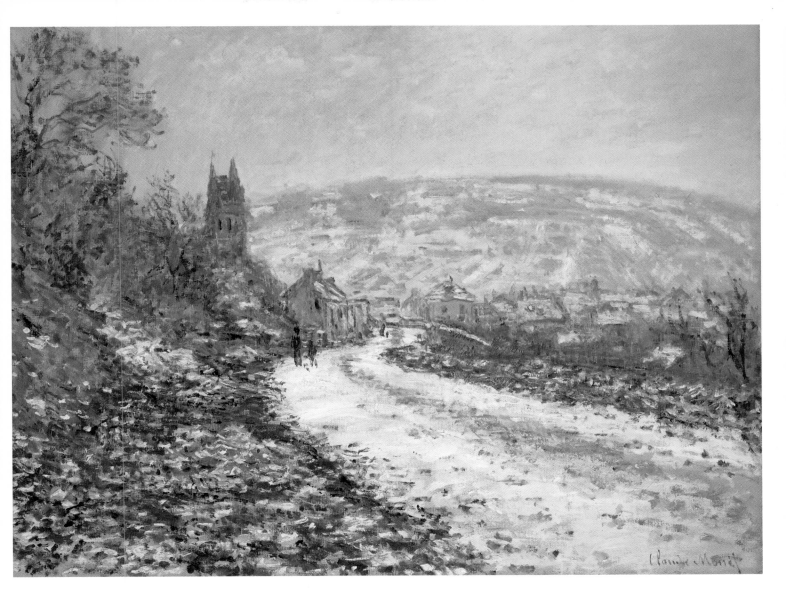

11
Entrance to the Village of Vétheuil in Winter
Signed, about 1879
Oil on canvas
23⅝ x 31¾ in. (60 x 80.6 cm.)
Gift of Julia C. Prendergast in memory of her
brother, James Maurice Prendergast
21.7

By the time Monet moved to Vétheuil in 1878 the Impressionists had held their third group exhibition, and the group was disintegrating under the pressures of continued public scorn and financial distress. Nevertheless, the indomitable Monet pushed further and further just those aspects of his painting that were most misunderstood by critics and public alike: his attempts to capture transient conditions of weather and light, and his ever freer, more summary brushwork. In this picture of 1879 Monet left much of the canvas uncovered or very thinly painted, using the unpainted areas as a positive color element to tame some of his brighter touches and to tie together areas of very different texture or intensity, as in the embankment on the left and the village buildings.

Monet had tended to repeat and rework a motif or composition until he had extracted all the possible variations of interest to him. At this time he began to make conscious efforts to repeat a particular scene under varying light and weather conditions, painting the route to Vétheuil under heavy snow and in bright spring sunlight. Repeating a successful composition allowed him to

focus his efforts more directly on the transitory effects that were his principal concern, and this method of working had the unexpected consequence of making his intentions and innovations more intelligible to his critics.
A.M.

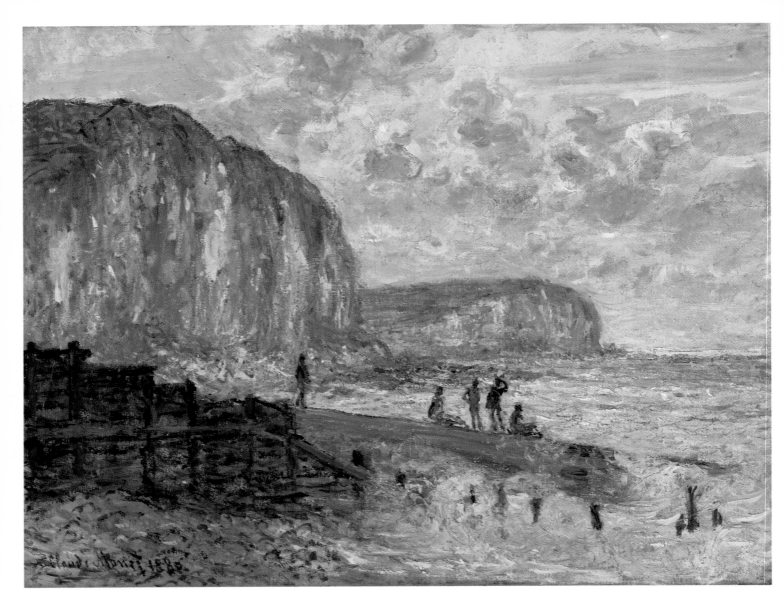

12
Cliffs of Petites Dalles
Signed and dated 1880
Oil on canvas
23⅝ x 31½ in. (60 x 80 cm.)
Ross Collection. Gift of Denman W. Ross
06.116

Throughout the 1860s Courbet had been a great influence and source of support for the younger Monet. Courbet's belligerent commitment to painting simply what he could see before him, and no more, was the foundation of Monet's work. In the 1870s and 1880s, references in Monet's work to Courbet were less frequent but more specific, occasionally extending to a borrowed motif such as *Cliffs of Petites Dalles,* which derives from the older artist's famous pictures of the cliffs at Etretat.

Even without Courbet, of course, Monet might have found the cliffs a logical subject; Petites Dalles is on the Normandy coast just above Fécamp, where Monet frequently painted. But Courbet's influence on Monet's paint textures, and on the thick slashing strokes that build up the cliff face, is unmistakable. Monet exploited his own facility with the brush to shape and mimic the different materials he depicted: loose splashy curls of paint for the waves crashing on the remnants of the breakwater; dry, drawn-out strokes for the crumbling wooden retaining wall; and layer upon layer of thick paint to re-create the texture of the cliffs themselves. The almost ghostly aspect of the figures on the shore emphasizes the materiality and power of both sea and cliff.

Petites Dalles marks the beginning of an interest in the rugged surface texture and imposing majesty of rock formations that would continue in Monet's work until well into the 1890s. In 1883, he would challenge Courbet directly with his own paintings of the Etretat cliffs, and in 1889 his first series paintings would concentrate on the rocky formations at the conjunction of the Creuse rivers.
A.M.

The surging sea and gusting wind were matched by Monet's flying brush. Rapid dashing strokes, laid on and then swirled further, churn the simulation of water on his canvas as the storm tossed the waves. He laid in the sky in sweeping strokes of pale gray blue, swept on the impastoed clouds, shadowed with blue-violet. Even the steady cliffs are portrayed with short, rough vertical strokes that suggest their rough texture.

Monet, ever a student of the moods of weather, left this stormy scene in a much less "polished" state than most of his landscapes. He was content that its very roughness best caught the feeling of the day.

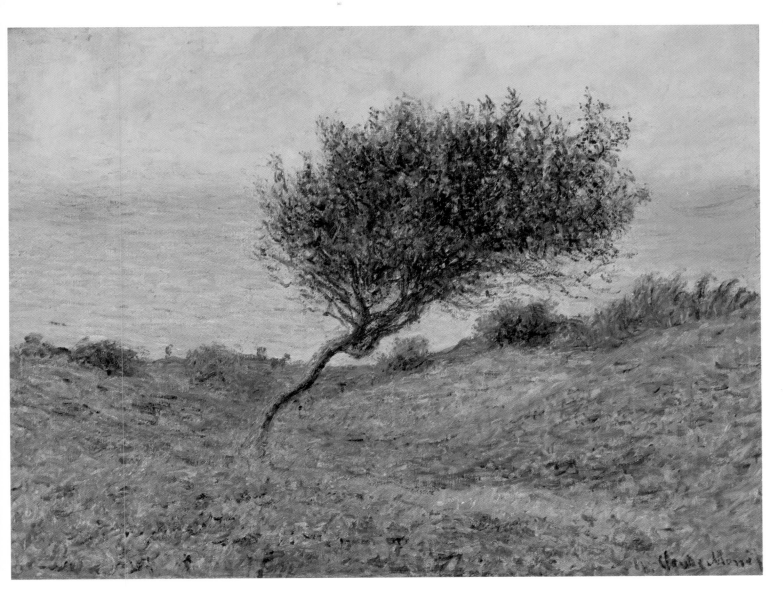

13
Sea Coast at Trouville
Signed and dated 1881
Oil on canvas
23½ x 31⅞ in. (59.7 x 81 cm.)
John Pickering Lyman Collection.
Gift of Theodora Lyman
19.1314

Monet's experiments with picture structure continued in the Normandy landscapes of 1881 and 1882. More and more he chose his views because their compositional possibilities, rather than their color, attracted him. In *Sea Coast at Trouville*, Monet borrowed the motif of a single wind-sculpted tree silhouetted against sea and sky from Millet, whose late Normandy landscapes and seascapes became a sourcebook for Monet in this period of struggling with composition. Where he had organized so many of his earlier works in depth, interlocking different planes with winding roads, the broad sweep of the Seine, or lines of trees, he now often laid out landscapes in distinct horizontal bands, eliminating the elements that tie foreground clearly to middle-ground and background. In *Sea Coast* distances are left uncertain, and the viewer has few clues to determine whether the tree is on a cliff far above the ocean, or in a meadow that runs nearly to the water's edge. Only small animals at the end of the field might provide a sense of scale, but they are so indistinct that they might be either cows or goats, so their relative size gives little help. To emphasize further the two-dimensional rather than the three-dimensional organization, the horizon line is suppressed and sea turns into sky. Such flat and decorative pictures as this bewildered Monet's colleagues, and marked his

turning away from the traditional spatial illusions that had been part of Impressionism in the 1870s.
A.M.

For this painting Monet chose white priming (which he used in every subsequent painting in this collection), a signal of his new interest in a more highly keyed palette. He left some of this priming exposed in the area of the sky, just as he had sometimes left exposed the tinted primings of his earlier work, using the tone of the priming as one value in the picture.

Paint becomes darker and more transparent with age. In passages that are thinly painted over a white ground such as this, the darkening effect is counterbalanced by the greater transparency of the film, these areas therefore retaining their original value.

14
Flower Beds at Vétheuil
Signed and dated 1881
Oil on canvas
36⅜ x 28⅞ in. (92.4 x 73.3 cm.)
John Pickering Lyman Collection. Gift of
Theodora Lyman
19.1313

The picture is unusual, although not unique, in juxtaposing a close-up screen of flowers against a deep landscape view. The middleground is suppressed, and the small boat with several figures, which should be well back in the painting, seems instead to hover over the flowers. This concern with denying distance can be seen in much of Monet's work throughout the 1880s, but here the problem is introduced without being resolved effectively. The contrast between the very freely painted flowers and foliage, so strident in color, and the distant, softly handled and mildly tinted river and hillside is jarring. The flowers seem out of focus and difficult to comprehend because the painter and viewer stand so close to them. They make a dramatic frame for a landscape view that is not sufficiently strong to counterbalance them.

Critics had predicted that Impressionism, determined to record simply and directly the variety of nature, would degenerate into banality and monotony. With paintings such as *Flower Beds*, Monet began to acknowledge this growing criticism by manipulating the viewpoint and the landscape elements, striving for a novelty in composition that he had earlier attempted only in color and technique.
A.M.

This painting, less satisfying as a work of art than many of Monet's works, is important in a different way. It represents the first stage in the development of a technique of handling paint that culminates more than ten years later in the treatment of the surfaces in the Cathedrals and Water Lilies.

Here, still in a rather rudimentary stage, we see in the sky a system of complex layering of paint of every hue. First the area was covered with blending strokes of pale yellow, yellow-green, violet, and, near the top, blue, all of about the same value. Over this went more bodied and discrete strokes of pink and vermilion or yellow-orange, barely mixed on the palette, rapidly dragged over certain areas as accents. Last, probably after the paint had dried, thin semi-transparent films of pale violet or pale yellow-green were dragged over most of the sky, subduing and unifying the many hues beneath, and giving the effect of intervening atmosphere.

This painting signals Monet's discovery of the inherent possibilities of the complex layering of paint, later developed in the paintings of Rouen Cathedral and of his garden.

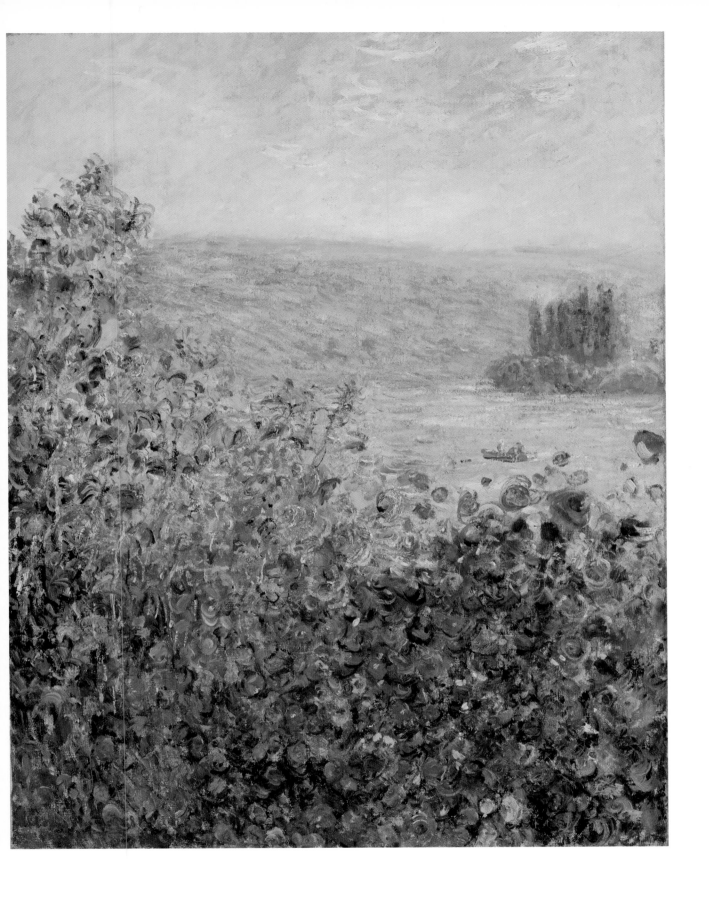

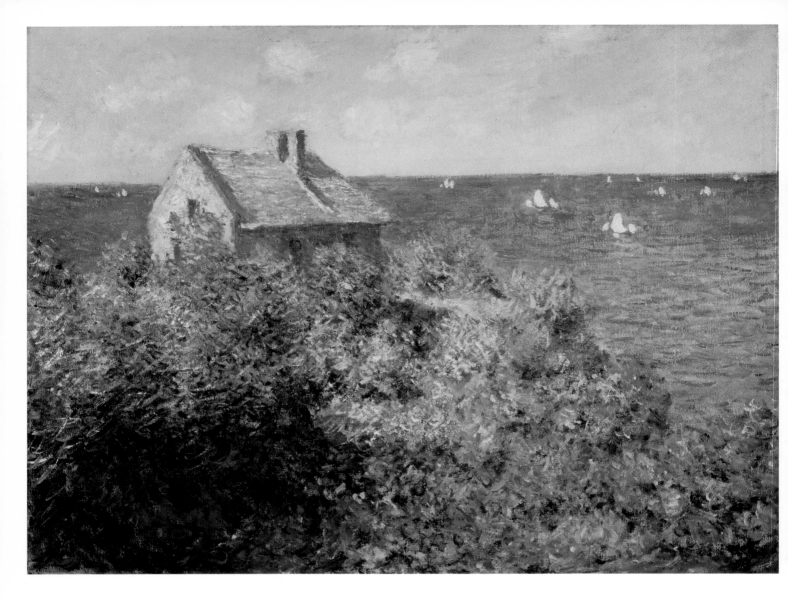

15
**Fisherman's Cottage on the Cliffs
at Varengeville**
Signed and dated 1882
Oil on canvas
24 x 34¾ in. (61 x 88.3 cm.)
Bequest of Anna Perkins Rogers
21.1331

Monet's regular summer trips to Normandy brought him in 1882 to Varengeville, a tiny village outside Dieppe. There, painting atop the overgrown cliffs, he found a new sureness in resolving the complex spatial problems he had set himself in recent pictures, and he turned once again to the bright surface rhythms of sparkling water and flickering leaves that marked his most vivid paintings of the 1870s.

Looking down on the fisherman's cottage from above, Monet was able to finesse the problem of the missing middleground by bringing the sea around the right side of the cliff, suggesting that the hut was indeed well above the water surface. The sea, which in turn threatens to rise as a flat blue-green curtain, is held down by the series of quickly executed sailboats, rapidly diminishing to single sharp strokes as they progress toward the horizon. With this ambiguous composition securely locked in space, Monet turned his attention to the mass of foliage that surrounds the cottage, piling up, in layer upon layer, an unusually wide and random range of colors. There is no attempt to define individual bushes or plants; all are merged in broad areas of light and shadow cast by the cliff above.
A.M.

Monet was a master in the placement of small accents of a different hue and value within a broad and relatively undifferentiated tone in a composition. Here the scale of the boats defines the vast extent of the sea. Their location and direction establishes a diagonal movement toward the center of the composition, as does the single sailboat in Cap d'Antibes: Mistral *(no. 24) or the line of red poppies at the lower right in* Poplars *(no. 7). Monet's preference for a design based on a crossing diagonal stems from an inherent feeling for balance, as though he were weighing the visual attraction of opposite sides of the composition in his two hands.*

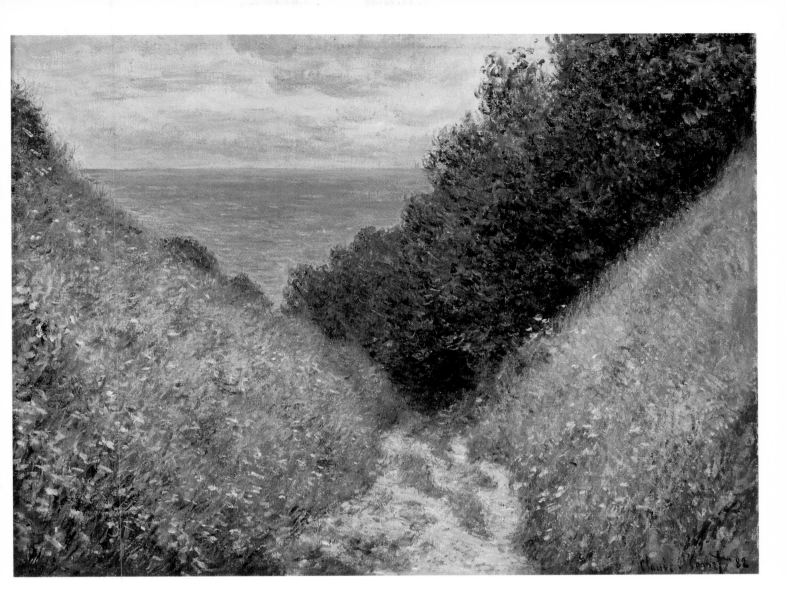

16
Road in a Hollow, Pourville
Signed and dated 1882
Oil on canvas
23⅝ x 32⅛ in. (60 x 81.6 cm.)
Bequest of Mrs. Susan Mason Loring
24.1755

The delicate pinks and pale golden greens that ripple through the grass-covered hillsides of *Road in a Hollow, Pourville* belie the daring of this unusual composition. No figures move along the footpath, no individual flowers or trees detach themselves from the broad triangular areas of color. Instead, an empty roadway draws the viewer's attention back to a dark, shady wall, where the path is lost below the trees; there, a sequence of sharp diagonals shift his gaze out over a deep view of flashing sea. This was Monet's most nearly abstract composition to date, and he made little effort to disguise the bold formal structure that supports it, only softening the hard lines with a few branches that break loose from the heavy green mass of trees, and with the glorious pink light that filters through the waving grasses along the edge of the hillside.
A.M.

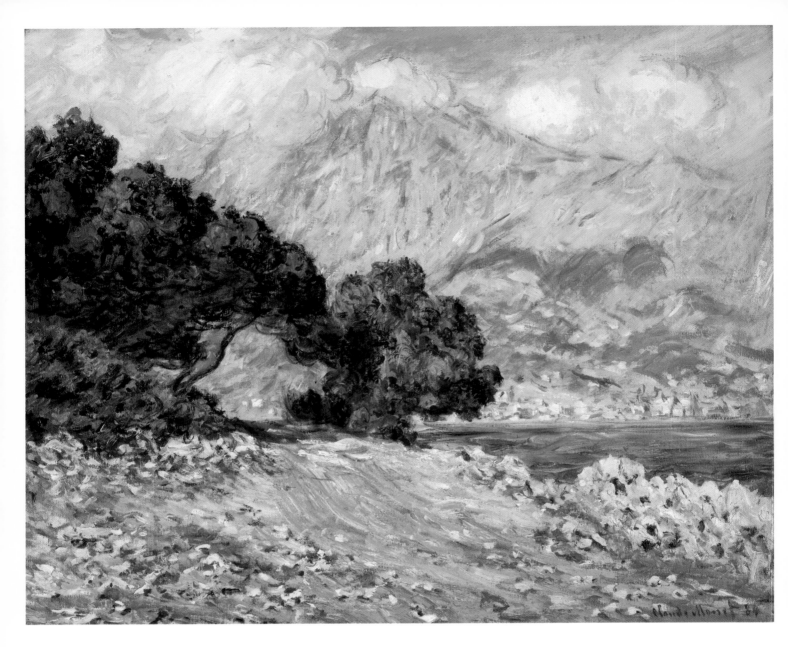

17
Cap Martin, near Menton
Signed and dated 1884
Oil on canvas
25¾ x 31⅞ in. (65.5 x 81 cm.)
Juliana Cheney Edwards Collection. Bequest of
Robert J. Edwards, and gift of Hannah Marcy
Edwards and Grace M. Edwards in memory of
their mother
25.128

Late in 1883, traveling with Renoir, Monet made
his first short visit to the Riviera. He was so taken
with the glittering sunlight of the southern coast
that by January of 1884 he was back for an
extended stay, painting at Menton and at Bor-
dighera, across the Italian border. He had come
by himself this time, explaining to his dealer,
Durand-Ruel, that it was absolutely necessary
that he be alone with his impressions. Those
impressions posed a whole new set of visual
problems, for the intense southern sunlight
strengthened and exaggerated the contrasts
inherent in the new scenery.

The wealth of textures in this view from Cape
Martin across the bay to Menton loosed the full
power of Monet's brushwork. The flamboyant
circular brushstrokes he used in *Flower Beds at
Vétheuil* (no. 14) are repeated in the pines that
arch across the roadway, but they are carefully
integrated into a composition marked throughout
by slashing strokes and heavy touches. Although
the color contrasts are sharp and vivid, and are
emphasized by the division of the canvas into
distinct color areas, Monet has scattered the
dark greens of the pines in small touches along
the roadway, and carried the strong orange-
pinks back into the trees and across the moun-

tains in a paler shade of the same hue, so as to
hold the vibrant colors tightly locked into place.

The bravura handling and the intensity of color
that mark *Cap Martin* and other paintings from
this Mediterranean stay are unusual in Monet's
work. They were not to be repeated in his later
visit to the south of France.
A.M.

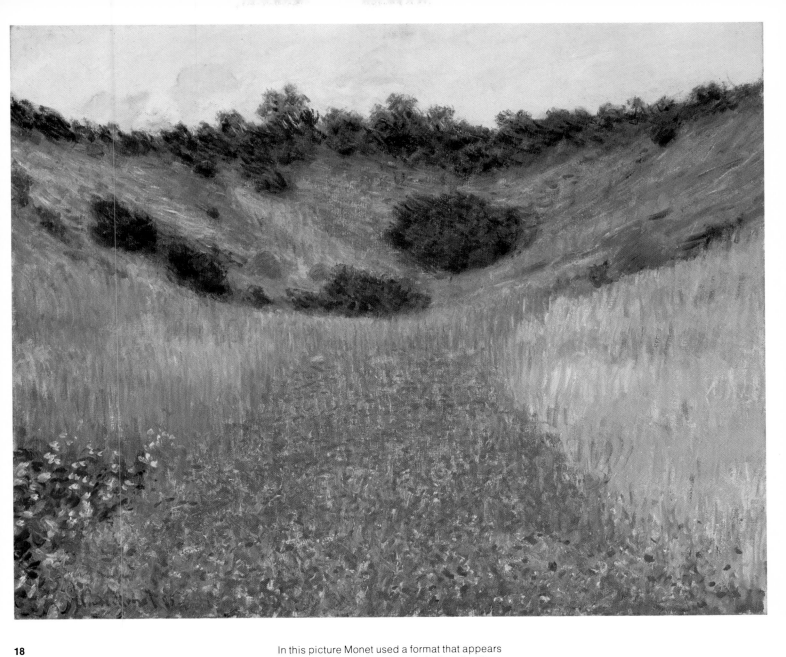

18
Poppy Field in a Hollow near Giverny
Signed and dated 1885
Oil on canvas
25¾ x 32 in. (65.4 x 81.3 cm.)
Juliana Cheney Edwards Collection. Bequest of
Robert J. Edwards in memory of his mother
25.106

In this picture Monet used a format that appears as early as the 1860s in *Rue de la Bavolle, Honfleur* (no. 2). The effect here, however, is not to produce an illusion of deep space. By 1885 Monet saw color and shape in nature as integral parts of an overall design. The triangular swath of poppies and the bordering meadow that curves up toward an undulating horizon under a hint of sky are less important for their own sake than for their function as shapes forming the composition. The effect of perspective is diminished by the flattening of these shapes, which are accentuated by directional brushwork, by their almost geometric arrangement on the canvas, and by the vibrating complementary red and green. Monet's intuitive use of color, the result of his intense perception and emotional response to nature, at times approaches the analytical results of his younger contemporary Seurat, who was imbued with color theory. Monet's fresh and uncontrived combination of colors in this picture contributes significantly to the success of the whole.
L.H.G.

19
Meadow at Giverny in Autumn
Signed, late 1880s
Oil on canvas
36¼ x 31⅞ in. (92.1 x 81 cm.)
Juliana Cheney Edwards Collection. Bequest of
Hannah Marcy Edwards in memory of her mother
39.670

Monet's move in 1883 to the village of Giverny, situated on the Seine halfway between Paris and Rouen, gave him a great deal of fresh subject matter, and he turned to the peaceful countryside surrounding his home (see also nos. 18 and 20) while he searched at the same time for more varied and dramatic material further afield. Poplars, visible in this picture only by the shadows cast across the sunlit meadow, are familiar features in Monet's Giverny landscapes. The high horizon line, varied application of paint, unusual high-keyed color combinations — pink and violet autumn foliage against yellow, blue, and green meadow grass — and rhythmic pattern of shadows all minimize the sensation of depth and draw the eye to a carefully composed surface. Despite the stronger contrasts of light that are typical of works of the 1880s, the landscape has a gentle aspect to which Monet's fluid curving brushstrokes and decorative use of color contribute.

Monet's Paris dealer, Durand-Ruel, included a *Meadow at Giverny* in the 1887 National Academy of Design exhibition in New York; similarly composed paintings are dated as late as 1894. Boston's version is undated, but comparison with others suggests that it can be placed in the late 1880s.
L.H.G.

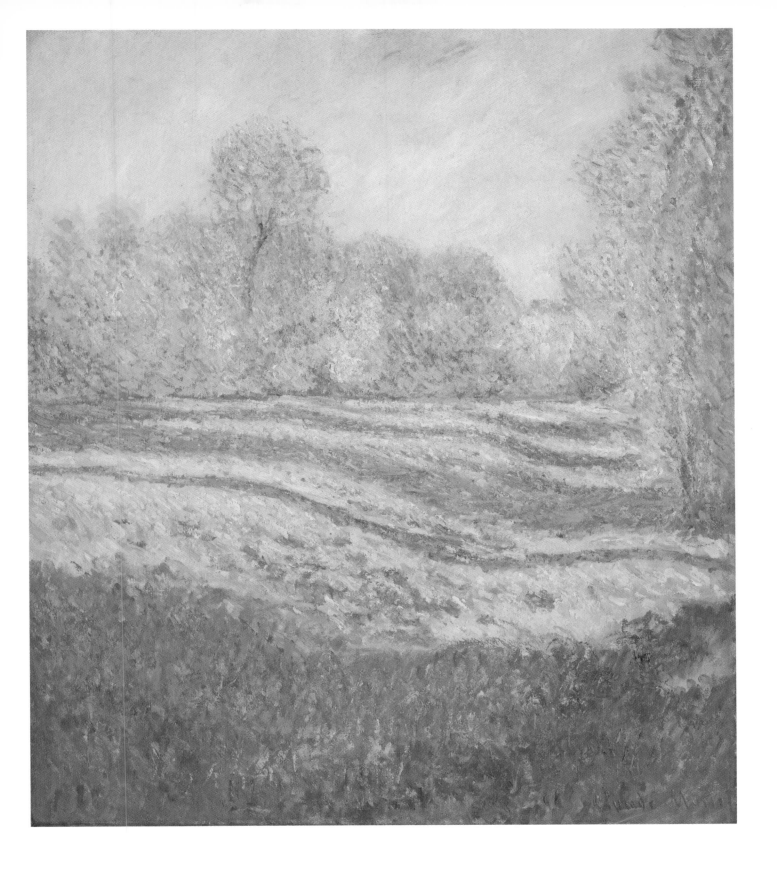

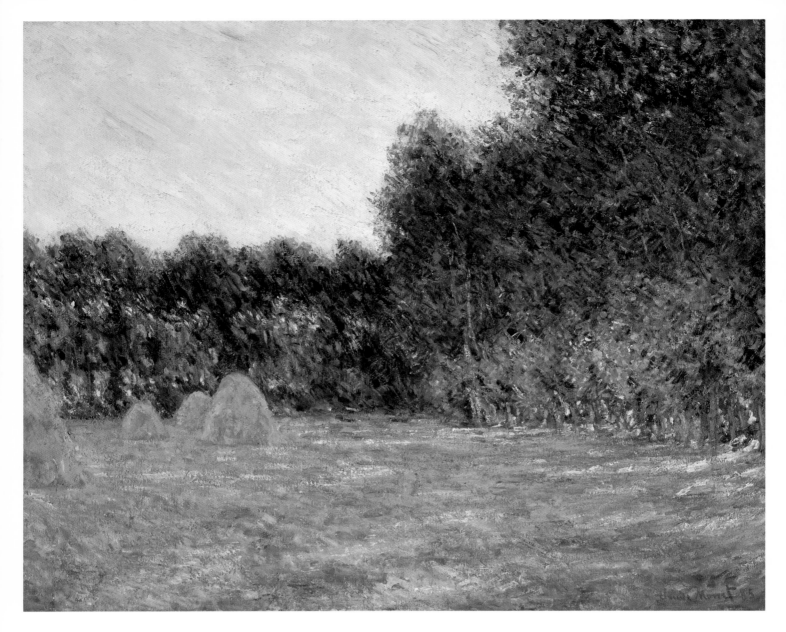

20
Meadow with Haystacks near Giverny
Signed and dated 1885
Oil on canvas
28⅝ x 36 in. (72.7 x 91.5 cm.)
Bequest of Arthur Tracy Cabot
42.541

In the 1880s Monet all but abandoned figures in his landscapes and concentrated on conditions of atmosphere and light in nature. Here the haystacks suggest man's presence, but no farming or domestic activity is evident. Monet noted instead light streaming in between trees at the edge of an empty clearing, altering form and color. The mounded haystacks turn pink in the afternoon light, the shaded side of the trees a deep blue-green. Presumably painted on the spot, the landscape appears, at the same time, to have been arranged. Monet has intentionally cropped a haystack on the left and combined in a pleasing manner the other haystacks and dappled spots of sunlight. The effect of recession produced by the diagonal line of trees and haystacks is lessened by the varied application and texture of paint: Monet's brush molds the haystacks, sweeps across the meadow, flickers in

the lower leaves of the trees, and forms diagonals in the upper branches that are echoed in the sky. The patterning of brushwork and light unifies the surface composition.
L.H.G.

Monet did his best to encourage the myth that he worked on his paintings only when he was actually present before his motif. We know, however, that he finished scenes from London and Venice, for example, in his studio at Giverny.

The condition of Meadow with Haystacks near Giverny *suggests that he may have reworked it after some time had elapsed. One might expect that Monet's complicated system of layering paint on fine canvas would result in technical problems as the paintings aged. For the most part, however, barring any later mechanical damage, they have come down to us in extraordinarily fine condition. Of all the paintings in the collection only this one exhibits "inter-layer cleavage," small areas in the sky where the top layer of paint has flaked off, revealing a lower layer. In the top left corner, for example, one can see a thinner pink film, and in another spot a thin pale green interrupting the heavily impastoed drag stroke of lightly mixed blue and white paint.*

Monet's brush did not miss these areas: the broken edges suggest that the top film has chipped away.

Since Monet's paint usually bonded so well to the lower layers, we search for an explanation for this unusual occurrence. It may be that the painting was set aside long enough for a thin film of grime to be deposited on the surface, just enough to prevent the continuous adhesion of the later layer to the first one.

The outlines of the trees were obviously readjusted after the second, more impastoed reworking of the sky. The blue paint of the top layer in the foliage is rather darker and more intense than the general tonality set in the beginning, as is the dark crimson used in the final layer of the shadows at the very center of the picture. This suggests that Monet might have been working in a studio with less intense light than he had found out of doors.

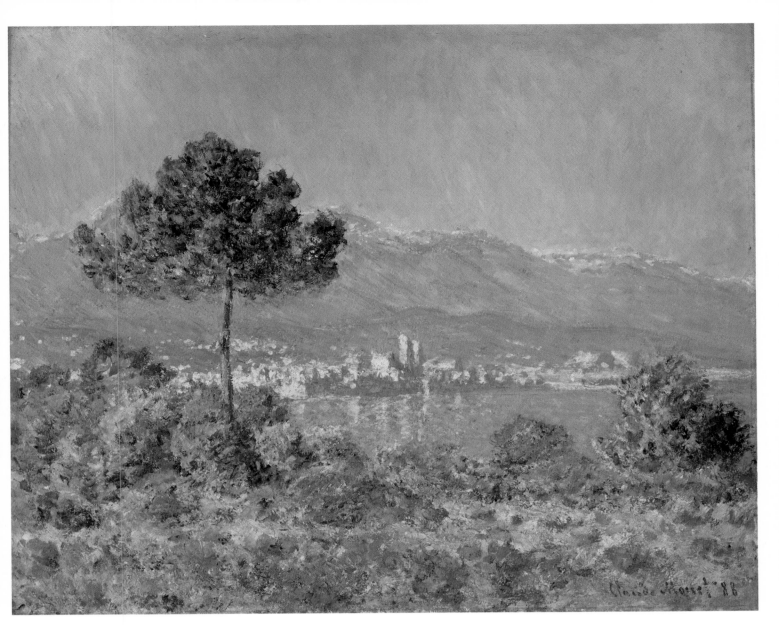

21
Stone Pine at Antibes
Signed and dated 1888
Oil on canvas
25¾ x 32 in. (65.4 x 81.3 cm.)
Juliana Cheney Edwards Collection. Bequest of
Hannah Marcy Edwards in memory of her mother
39.672

22
Old Fort at Antibes (I)
Signed and dated 1888
Oil on canvas
25¾ x 31⅝ in. (65.4 x 80.3 cm.)
Gift of Samuel Dacre Bush
27.1324

23
Old Fort at Antibes (II)
Signed and dated 1888
Oil on canvas
25¾ x 31⅞ in (65.5 x 81.0 cm.)
Anonymous Gift
1978.634

The paintings from Monet's second Mediterranean visit, to Antibes and Juan-les-Pins in 1888, are paler and more delicate in hue than those from his earlier stay at Menton. Pink and light blue, rather than vivid orange and dark green, are the dominant colors. The later works are no less suffused with light than the Menton pictures, but it is softened light, which Monet exploited for unifying rather than contrasting properties.

The old fort dominating the town of Antibes was Monet's favorite motif during this campaign, and he painted it from every possible viewpoint. He was attracted by the subtle changes that took place in the very closely related hues of sea, town, and mountains as the day and the season progressed. For a number of paintings, Monet chose an almost severe composition of parallel bands of sea, mountains, and sky. Above the old fort the sky is thinly and smoothly painted in a turquoise tint that fades to yellow-green along the mountains; below, the sea is a flickering expanse of short, staccato streaks of green, blue, and lavender touched with pink. The contours of mountains, fort, and promontory below are carefully adjusted to one another. Only four colors are used – creamy-yellow, pink, lavender, and blue – but every shift in building plane, rooftop, or mountain edge is marked with a subtle modulation of

hue. The old fort's complex of buildings acts as a many-faceted gem, splintering the light of the rising sun.

While unpainted canvas shows through much of the thinly and quickly painted old fort pictures, the *Stone Pine at Antibes* is thickly and drily articulated with many superimposed touches of paint that build up a crusty surface. The fort and surrounding buildings across the bay are too far away to be read coherently as architecture, and Monet, more interested in the drama of sunlight and shadow than the specific identity of the town, reduced them to thick, rhythmic touches of yellow and blue paint. Framing the fort are mountains, now heightened, and a solitary pine strategically placed.
A.M.

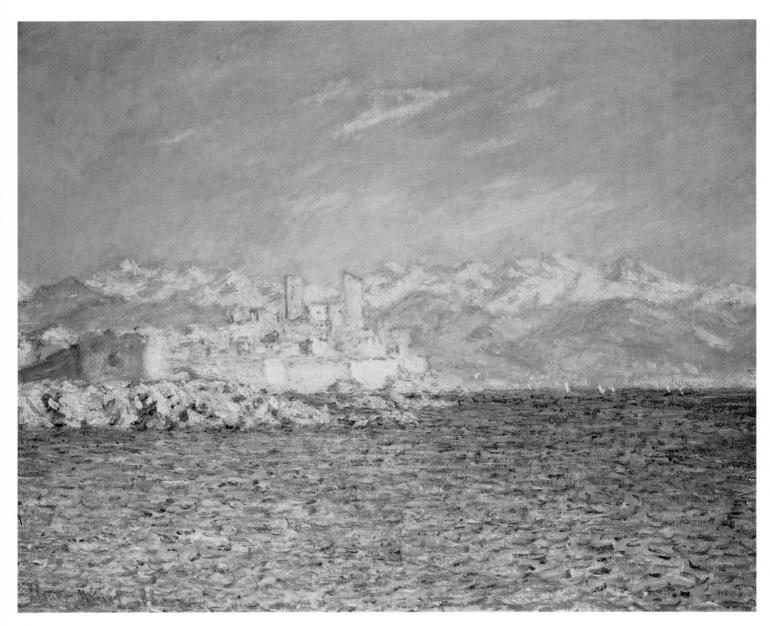

22
Old Fort at Antibes (I)

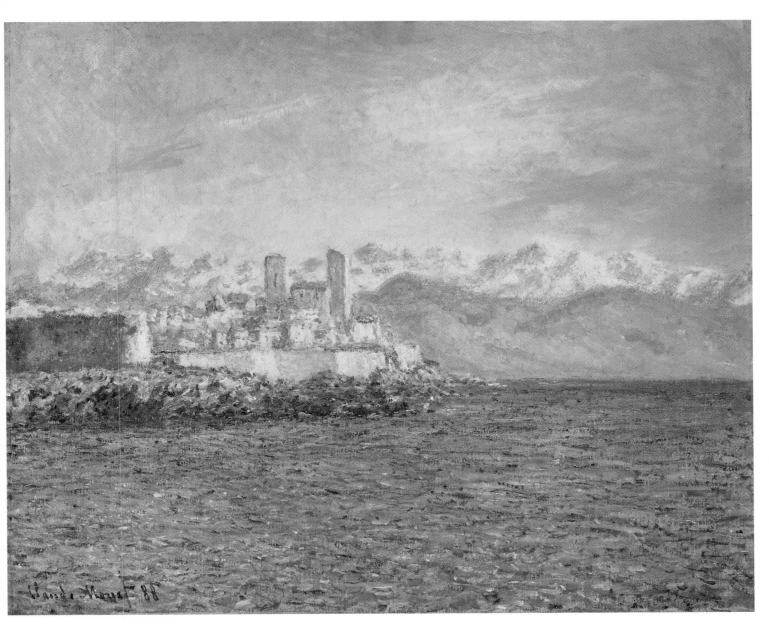

23
Old Fort at Antibes (II)

24
Cap d'Antibes: Mistral
Signed and dated 1888
Oil on canvas
25⅝ x 31½ in. (65.1 x 80 cm.)
Bequest of Arthur Tracy Cabot
42.542

The mistral, or cold northerly wind that sweeps down upon the Mediterranean, seems to have dimmed the sunlight at Antibes only slightly, softening the colors and easing some of the glare, although the chill has deepened and intensified the blue of the sea. For Monet, its appeal lay in the movement of the trees and grasses under the force of the wind. In this variant of the horizontal compositions he favored during his 1888 stay along the Riviera, he holds our attention to the foreground, concentrating on the swaying grasses and the forcibly bent branches of the trees. To capture a sense of motion in an otherwise static composition, he abandoned most of the small soft touches of the Old Fort paintings, and used long, curved strokes that pile upon one another to convey the whipping motion of the wind.
A.M.

Monet used an extensive range of brushstrokes, from wash in the sky to tiny strokes in the tree. His sure technique of drawing with brush is evident here in the boat, which is laid in with only five touches. The brilliant light in this picture is perhaps the highest keyed of all the Museum's works by Monet.

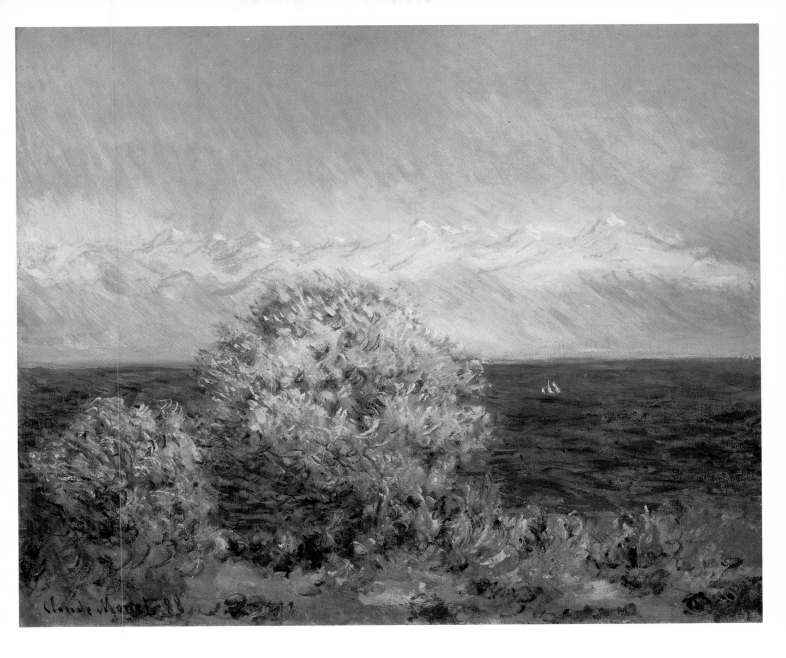

25
Ravine of the Creuse I
Signed and dated 1889
Oil on canvas
26 x 36¾ in. (66 x 93.5 cm.)
Juliana Cheney Edwards Collection. Bequest of
Robert J. Edwards in memory of his mother
25.107

26
Ravine of the Creuse II
Signed and dated 1889
Oil on canvas
25½ x 31 in. (64.8 x 78.7 cm.)
Ross Collection. Gift of Denman W. Ross
06.115

27
Ravine of the Creuse III
Signed and dated 1889
Oil on canvas
25¾ x 32 in. (65.5 x 81.3 cm.)
Bequest of David P. Kimball in memory of his
wife, Clara Bertram Kimball
23.541

Monet had been repeating or adapting the same compositions for years. He had painted the route to Argenteuil in bright spring sunlight, through a haze of falling snow, and under a layer of that same snow several inches deep. He repeated the basic compositional elements of the *Road in The Forest* (no. 1) in a dozen other combinations. He found the old fort at Antibes so compelling he depicted it from at least six different vantage points. Most of these repetitions were random and fortuitous. The paintings were independently conceived and meant as distinct, complete works of art.

In 1889, however, this process of repetition took on a new meaning. With the *Ravines of the Creuse*, Monet consciously began to view several paintings of a single motif or composition as interrelated and, more important, interdependent. He worked on several paintings simultaneously, devoting himself to each one only as long as the light or weather held constant. In a three-month period he painted several panoramic views of the junction of the Grande and Petite Creuse Rivers from a number of different viewpoints at different times of day; he painted a number of pictures that focused on the rapids where the rivers ran together; and he produced at least one painting in which the canvas is entirely filled by a single massive rock that marked the river juncture. In all these, he would claim later, he was searching for "instantaneity," for the precise, limited visual effect that summed up the experience of a particular moment. Instantaneity is frequently defined in terms of transitory color effects of changing light and weather, but the problem Monet set himself was greater than simply registering the color effect of an isolated moment. He could no longer accept the Impressionist claim that truth to nature lay in the carefully rendered single visual experience. As those single instants became increasingly refined, he found it necessary to present a series of views, his cumulative confrontation with interacting forces of weather, light, and material.

Ravine of the Creuse I and *Ravine of the Creuse II* both record the same broad sweep of hilly Berrichon countryside along the Creuse River, the first in the full glare of midday sun, the other at early twilight. In the bright light, all the contrasts in the landscape are emphasized: the boulders on the riverbank stand out in strong relief; the variety of greens, yellows, and purples in the foliage and rock-strewn fields is exaggerated; and the succession of overlapping hills along the winding river recedes clearly back to a far distant tree-topped ridge. In the rapidly vanishing light of early evening the boulders disappear against the hillside, all the colors soften and merge in a narrower range of dark blues and purples — all, that is, except the greens, which take on a new intensity — and darkness seems to dissolve the hills into a single rocky wall.

Monet changed the nature of the Creuse landscape dramatically when he shifted his view to the riverbed in *Ravine of the Creuse III*. The low, rounded hillsides become a series of steeply angled rocky slopes, rising high above the small stream, when one looks up along the riverbanks rather than across them. Slashing, harsh red-purple strokes define a rough, ragged terrain very different from the mix of grass and boulders suggested in the other Creuse views. The late hour lengthens the shadows without yet softening the outlines of the rocks or hillsides.
A.M.

These and the Cliffs of Petites Dalles *(no. 12) are the only ones by Monet in the collection that have rip crackle, the wide cracks visible in dark passages here, which is caused by the application of a faster-drying paint layer over one that is not yet fully set. The insufficient drying time Monet gave these pictures may have something to do with the fact that he was traveling at the time.*

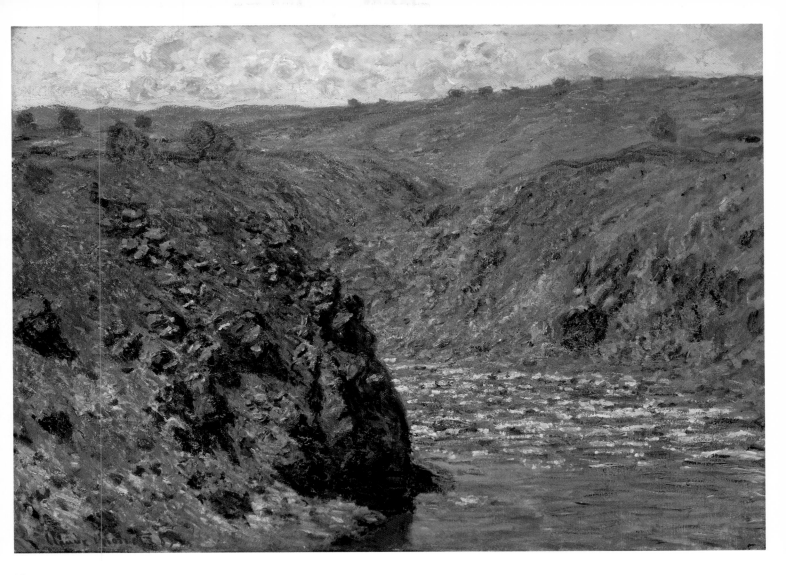

25
Ravine of the Creuse I

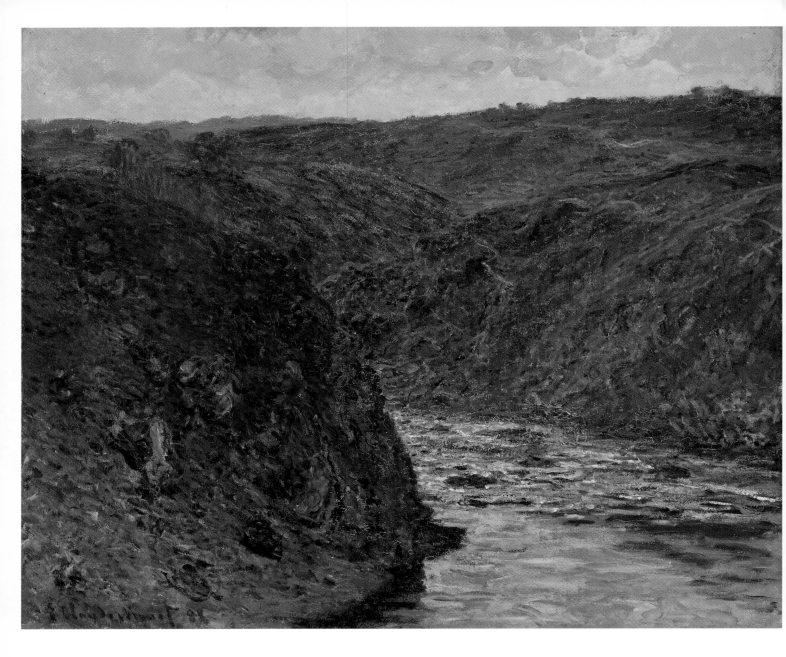

26
Ravine of the Creuse II

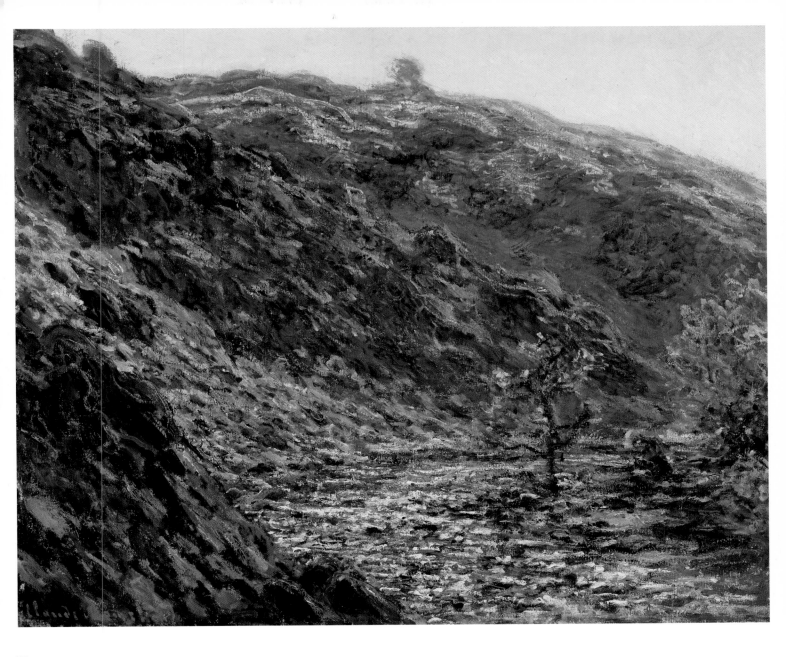

27
Ravine of the Creuse III

28
Field of Poppies near Giverny
Signed and dated 1890
Oil on canvas
23⅞ x 39⅜ in. (60.6 x 100 cm.)
Lent by the Trustees of the White Fund,
Lawrence, Massachusetts

With the Creuse paintings of 1889, Monet had discovered that a number of variations could be worked on one landscape theme under different conditions of light and atmosphere, and this discovery worked powerfully on his imagination. *Field of Poppies near Giverny* exists in two versions, nearly identical in composition but quite different in coloring, the two paintings possibly representing a search for another landscape motif that could stand up to repeated examination at every hour, during every season. Perhaps in returning to subjects that had captured his attention frequently in the past, the brilliant red hue of poppies and the tall, slender forms of poplar trees, Monet hoped to find the elemental aspects of color and structure that had made intensive examination of the Creuse ravine so rewarding. But because living motifs are so transient and subject to seasonal changes, they could not provide for him the underlying stability and materiality that unites the diverse paintings of the rocky slopes of the *Ravines*, whose basic substance remains the same through all seasons. We know, for instance, that while Monet painted the Creuse pictures during the winter and early spring of 1889, he hired a man regularly to prune away the budding leaves of a tree, not wanting nature to disturb his composition. Monet would later turn to the enduring forms of haystacks and cathedrals for subsequent series paintings.

Of course, the *Field of Poppies* need not have been a prospect for serial painting, but simply a return to a familiar and favorite subject matter. Where earlier poppy paintings are characterized by a sure, quick response to light and color, however, the crusty, thick paint surface of this later version suggests considerable reworking and a growing concern with paint texture.
A.M.

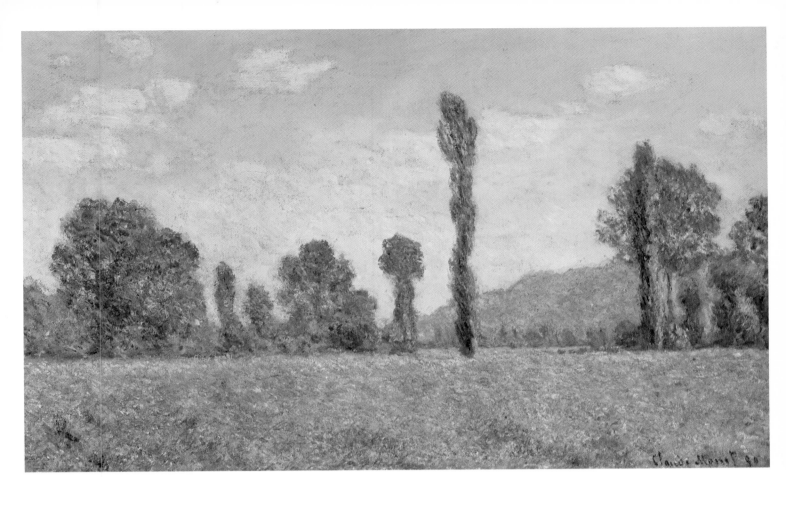

29
Haystack at Sunset
Signed and dated 1891
Oil on canvas
28¾ x 36¼ in. (73 x 92 cm.)
Juliana Cheney Edwards Collection.
Bequest of Robert J. Edwards in memory of
his mother
25.112

30
Haystack in Winter
Signed and dated 1891
Oil on canvas
25¾ x 36⅜ in. (65.4 x 92.3 cm.)
Gift of the Misses Aimée and Rosamond Lamb
in memory of Mr. and Mrs. Horatio A. Lamb
1970.253

The Haystack series, probably begun in 1890, illustrates Monet's systematic and concentrated involvement with the same motif examined repeatedly under changing conditions of light and atmosphere. His turn to serial painting is understandable in view of his lifelong interest in transitory effects of nature (an interest awakened by the open-air studies of Boudin and Jongkind, with whom Monet worked in his youth) and in view of his later practice of repeating a motif. Monet carefully rendered on separate canvases the varying ephemeral atmospheric effects on the same motif, so that each work in the series is complete in itself, but is also part of a continuous record of changes. He observed intensely on the spot, yet later reworked the pictures from memory, admitting that conditions were so fleeting that he found it difficult to render "instantaneity."

As early as 1884 and 1885 Monet was painting haystacks in the fields around his home at Giverny (see no. 20). He was attracted by their form, not by the political and poetic association with farm labor and bucolic country life that they had had for Millet and the Barbizon painters a generation earlier. The series paintings of 1890 and 1891 are simpler still, with few details. Here farmhouses, haystack, hills, and fields are flattened shapes of color, sometimes strident but lacking sharp contrasts of value. Brushstrokes are compact and even more arbitrarily patterned than in earlier works, further diminishing the illusion of solid volume. The surrounding "envelope" of which Monet spoke (see no. 31) has assumed greater importance than the motif itself.

When a large group of Monet's paintings of haystacks was exhibited at Durand-Ruel in 1891, fifteen were sold in three days. After a lifetime of indifferent or hostile reception by the public, Monet's career had undergone a decisive change. That June the painter Theodore Robinson wrote to a friend, "Don't fail to see some of his last winter's work, at Durand-Ruel's and elsewhere, it is colossal, something of the same grave, almost religious feeling there is often in Millet...."

The purple and olive-green haystack shown in the light of early morning, set on a bluish, pink, and yellow snow-covered field, seems even less palpable than that of no. 29. It looms from its shadowed base, yet its substance is dissolved into particles of light. By perceiving color created by light and reflection, Monet painted snow, which has no inherent color, as dazzlingly polychromatic.

These pictures by Monet amazed and attracted the twenty-nine-year-old Kandinsky. Recalling his experience of a painting from Monet's haystack series in a Moscow exhibition in 1895, he later wrote, "Suddenly, for the first time, I saw a 'picture.' That it was a haystack, the catalogue informed me. I could not recognize it. This lack of recognition was distressing to me. I also felt that the painter had no right to paint so indistinctly. I had a muffled sense that the object was lacking in this picture, and was overcome with astonishment and perplexity that it not only seized, but engraved itself indelibly on the memory and, quite unexpectedly, again and again, hovered before the eye down to the smallest detail. All of this was unclear to me, and I could not draw the simple consequences from this experience. But what was absolutely clear to me was the unsuspected power, previously hidden from me, of the palette, which surpassed all my dreams. Painting took on a fabulous strength and splendor. And at the same time, unconsciously, the object was discredited as an indispensable element of the picture...."
L.H.G.

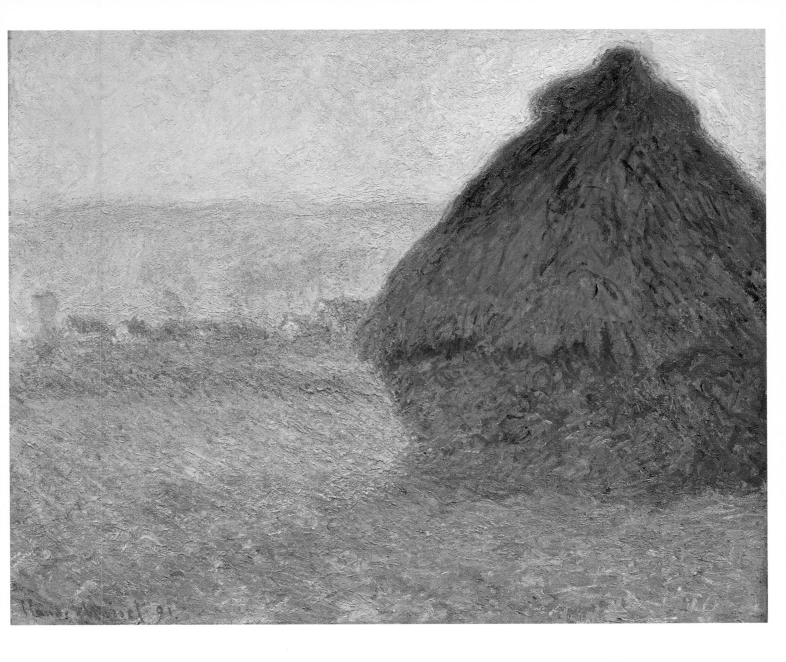

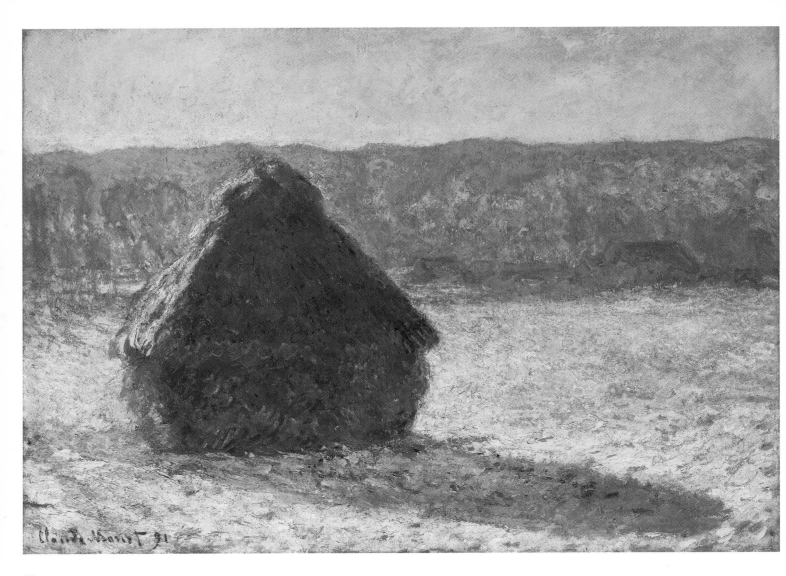

30
Haystack in Winter

31
Rouen Cathedral at Dawn
Signed and dated 1894
Oil on canvas
41¾ x 29 in. (106 x 73.7 cm.)
Tompkins Collection. Purchased, Arthur Gordon
Tompkins Residuary Fund
24.6

32
Rouen Cathedral at Sunset
Signed and dated 1894
Oil on canvas
39½ x 25¾ in. (100.3 x 65.5 cm.)
Juliana Cheney Edwards Collection.
Bequest of Hannah Marcy Edwards in memory
of her mother
39.671

(see following pages)

Much of the significance in Monet's early work lies in the fundamental importance he attached to painting everyday reality, to demonstrating the range of visual variety and excitement in common landscape views to which few people gave much notice. When, in contrast, he turned his attention to a major medieval monument (which his entire audience would have prided themselves on knowing well), the west façade of Rouen Cathedral, Monet made his own vision the critical issue, rather than any significance or lack of it in the landscape itself. Monet was declaring that no one had really seen the cathedral façade until one had seen it at least twenty times, in different lights at different seasons — as Monet himself had seen it.

The risk Monet was taking was great, even if seldom noticed. A national treasure, Rouen was repeatedly reproduced in prints, paintings, and, by 1892, even in photographs. In such a restricted view of the church, from which Monet consciously removed all identifiably religious symbols, notably the cross at the apex of the central tower, the potential for becoming trivial was always in front of him. It is a tribute to his consummate skill as a colorist, his unshakable faith in the importance of his method of painting in series, and also the majesty of Rouen Cathedral, that the exhibition of twenty cathedral paintings in 1895 was his greatest critical and popular success.

Both *Rouen Cathedral at Dawn* and *Rouen Cathedral at Sunset* show similar views of the West Portal and the Tour St. Romain, painted from the second-floor window of a building across the square. Monet's viewpoint shifts only slightly between the two paintings, including buildings at the base of the Tour St. Romain in the *Cathedral at Dawn,* and part of the Tour de Beurre in the *Sunset* painting. The fundamental change between the paintings is the sunlight, touching only the upper portion of the Tour St. Romain as the sun rises over the eastern end of the Cathedral, and illuminating the full façade as it sets. But with the change in the direction of the sunlight, the entire atmosphere seems to change. With the full light of the setting sun, the very air becomes charged with light as the thousands of stone details break up the sunlight and reflect it in all directions; at dawn, the same details seem to hug the shadows, swallowing what little light escapes around the tower, making the façade much darker but unexpectedly more legible. Monet called this shimmer of light the *enveloppe,* and repeatedly complained of the great difficulty in capturing the appearance of the cathedral as the *enveloppe* changed with the light or the season.

As Monet struggled with the fleeting effects, working and reworking the picture surface, the paint took on the rough texture of weathered stone, so that the paintings begin to collect and reflect light much as the cathedral façade.
A.M.

In Rouen Cathedral at Dawn *Monet was seeking to capture the coruscation of light as it fell on the faceted surfaces of the stone. There are very few continuing strokes marked by the brush bristles. Only in the rose window can we identify the use of a small loaded brush. The thick, heavily bodied paint seems to have been applied by stabbing it on with a stiff brush. It has been suggested that some of the heavier paint was loaded on with a palette knife, but this seems unlikely, as we can find no trace of such a tool. The unusual texture of the paint was developed for a specific optical effect.*

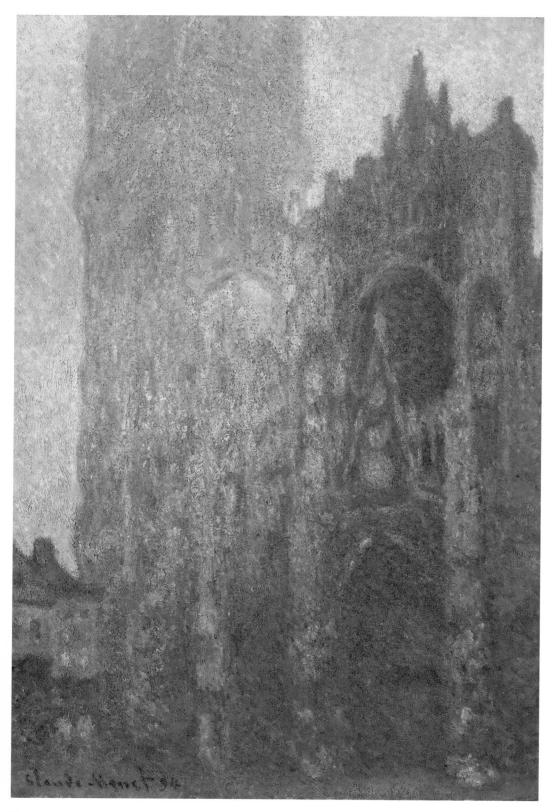

31
Rouen Cathedral at Dawn

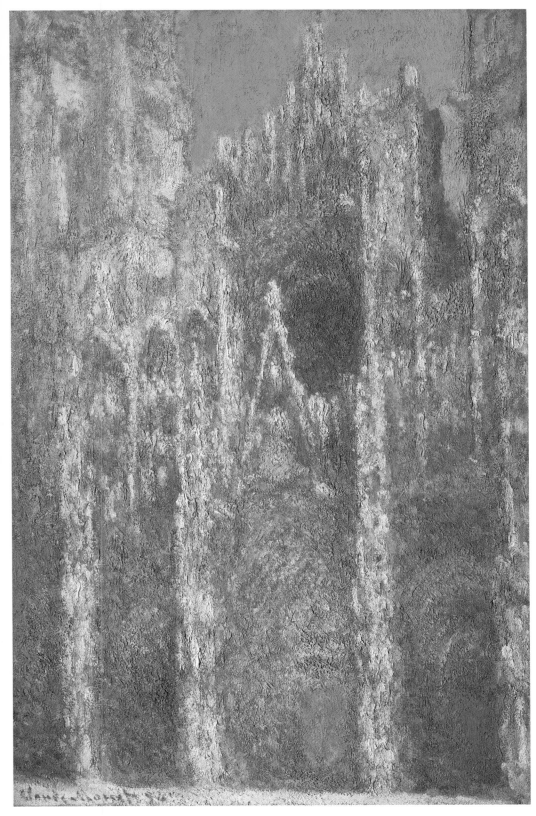

32
Rouen Cathedral at Sunset

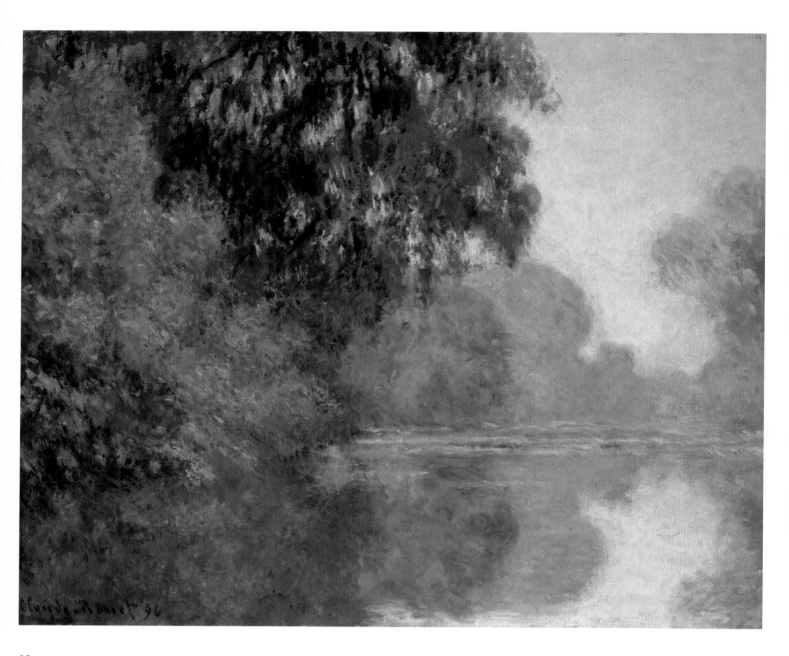

33
Branch of the Seine near Giverny I
Signed and dated 1896
Oil on canvas
28⅞ x 36⅜ in. (73.5 x 92.4 cm.)
Juliana Cheney Edwards Collection. Bequest of
Grace M. Edwards in memory of her mother
39.655

34
Branch of the Seine near Giverny II
Signed and dated 1897
Oil on canvas
32⅛ x 36⅜ in. (81.6 x 92.4 cm.)
Gift of Mrs. Walter Scott Fitz
11.1261

With the Mornings on the Seine series, painted during the summers of 1896 and 1897, the river again became Monet's visual stimulus. From a position along a tributary of the Seine near his home at Giverny, Monet observed subtle and minute changes of color and tone in the dawning light. The view is nearly constant within the series, the river overhung with trees that recede in the distance, allowing trees, sky, and water to converge. Variations occur only as the morning light intensifies over the quiet river shrouded in mist, which is conveyed by Monet's smoother application of paint, without broken strokes or impasto, and by a pervasive close range of blues and purples.

In the 1896 version the sun has risen high enough to dissipate some of the haze. The gray-green trees in the foreground stand apart in color and delineation from the still shadowy, flattened blue-green trees along the low horizon. Light has just

emerged in the 1897 version, not yet disturbing the bluish-purple tonality. Brushstrokes are unobtrusive and forms simplified into silhouettes; only the elevated horizon line differentiates the reflection from its source. Foliage and sky and their counterparts on the surface of the water are mirror images of each other, balanced within a nearly square format.

Monet's earlier paintings of the Seine portrayed an active river, flowing past towns and supporting boats. Later, in this series, the river is becalmed and mist-laden, anticipating Monet's preoccupation with atmosphere over the Thames (no. 36) and the canals of Venice (no. 39). Reflections on water are more closely examined in the Water Lilies series (nos. 37 and 38).
L.H.G.

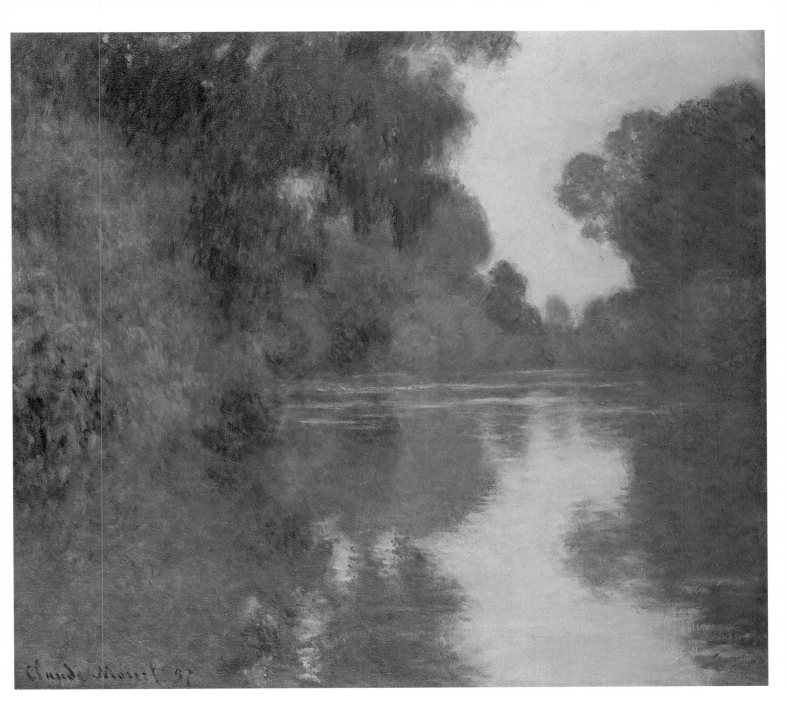

The diffuse misty light brings the values into a narrow range. The hues are also limited to cool greens and lavender-blues and the pale mauve of the sky and its reflection in the water, with a few touches of darker green or purple for the shadows.

Within these limitations the colors shift. Each stroke is soft-edged, blending into its neighbors, except for the finest threads of white highlights in the water, which serve to establish the plane of this reflecting sheet.

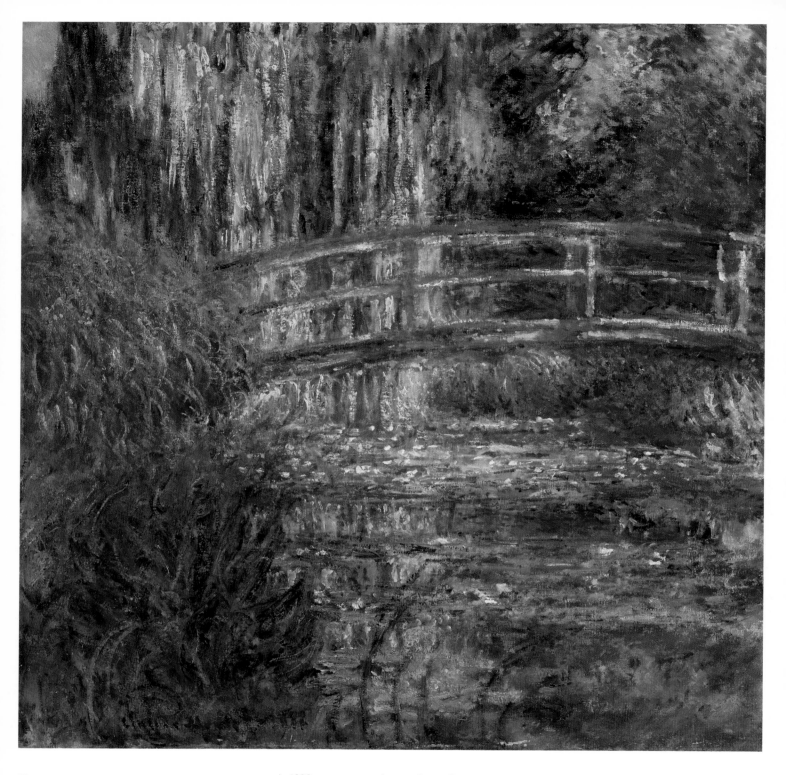

35
Water Garden and Japanese Footbridge
Signed and dated 1900
Oil on canvas
35 x 36¼ in. (89 x 92 cm.)
Given in memory of Governor Alvan T. Fuller by
The Fuller Foundation
61.959

In 1890, seven years after settling at Giverny, Monet bought adjacent property, which became the nucleus of his water garden. A tributary of the Epte River that flowed through it and a dredged pond provided a setting for various species of water lily and other aquatic plants. The far bank of the pond was joined to the rest of the property by a footbridge, inspired by a Japanese print.

Monet's serial views of the water garden began in 1899. Contemporary photographs of the garden indicate that Monet altered the scene very little, although he was selective of what he chose to paint, and how. Overlapping vigorous brushstrokes of red, violet, blue, and green pigment in varying lengths — long arcs for foliage, short

flicks for reflections in the water, broad horizontal strokes for the bridge — densely cover the canvas. Water, plants, and bridge all have equal emphasis; the brushstrokes no longer gently describe form but are themselves the primary focus of the picture. The visual profusion of this natural world of Monet's own devising is stabilized by the traditional means of corresponding rhythms and rectilinear organization.
L.H.G.

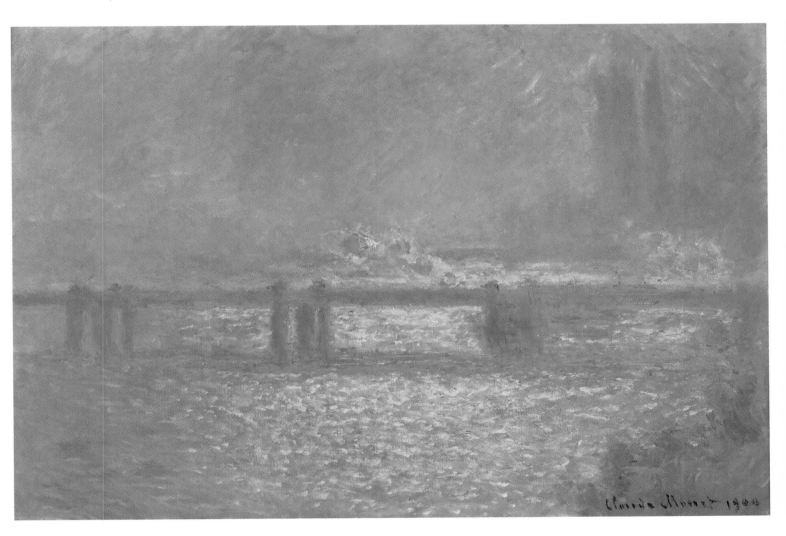

36
Charing Cross Bridge
Signed and dated 1900
Oil on canvas
23⅞ x 36 in. (60.6 x 91.5 cm.)
Given by Janet Hubbard Stevens in Memory of
her mother, Janet Watson Hubbard

Monet worked in London in the fall of 1899 and in the two succeeding winters. He spoke of his preference for London in winter with its "mysterious mantle" of fog. From his balcony in the Savoy Hotel overlooking the river, Monet looked down on the rigid form of the Charing Cross railroad bridge and the Houses of Parliament in the distance. The structures in the painting, broadly painted in flat areas of muted color, establish a geometric surface order that underlies the atmospheric whole. Monet eliminated all specific detail in this painting and restricted his palette to insubstantial pale blues, pinks, cream, and yellow to suggest winter mists on the river. Only the puffs of train smoke and flicks of yellow light on the water seem to penetrate the fog.

Thirty years earlier, in the fall of 1870, Monet had taken refuge in London from the Franco-Prussian War and occupied himself painting London parks and the Thames. In his turn-of-the-century Thames series, comprising almost one hundred paintings, Monet restricted himself to three motifs visible from the river, the Houses of Parliament, Waterloo Bridge, and Charing Cross Bridge. At this time Monet made contact with Whistler, whose work he admired; a connection can be seen in the flattened, atmospheric quality of Monet's Thames series.
L.H.G.

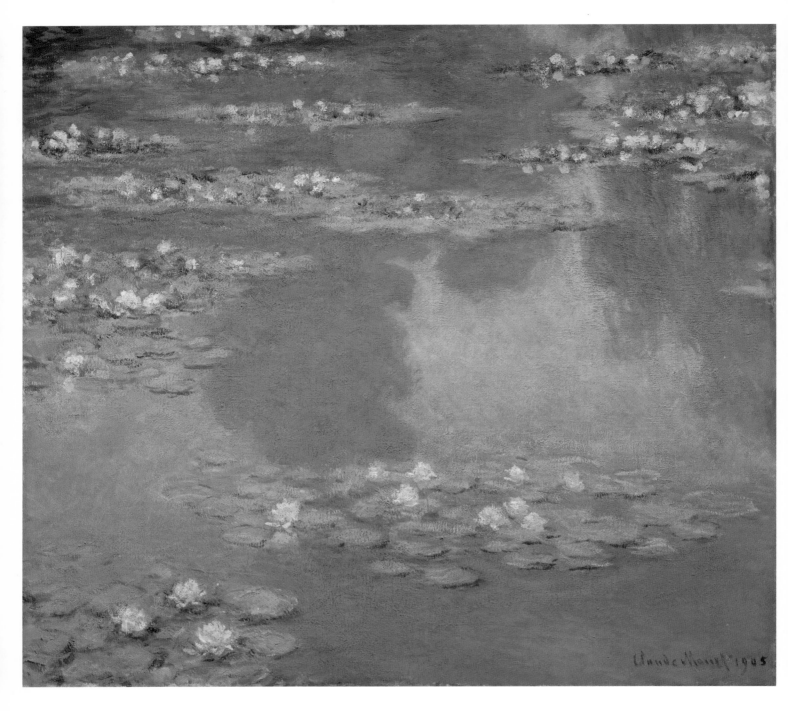

37
Water Lilies I

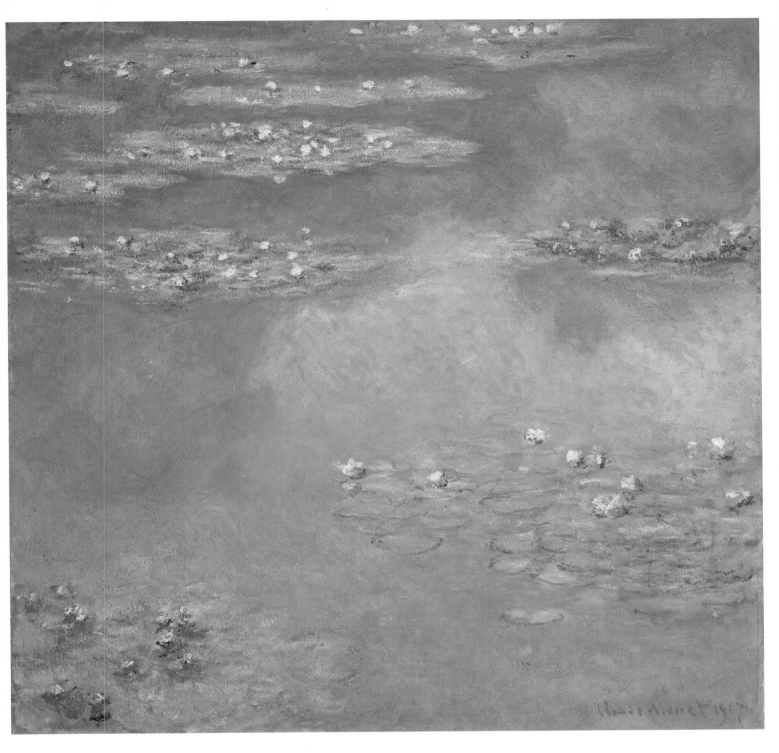

38
Water Lilies II

37
Water Lilies I
Signed and dated 1905
Oil on canvas
35⅛ x 39½ in. (89.2 x 100.3 cm.)
Gift of Edward Jackson Holmes
39.804

38
Water Lilies II
Signed and dated 1907
Oil on canvas
35⅛ x 36¾ in. (89.3 x 93.4 cm.)
Bequest of Alexander Cochrane
19.170

Reflections on water occur in the paintings of the late 1860s, but it was not until his Mornings on the Seine series of 1896 and 1897 (nos. 33 and 34) that Monet began to blur the boundary between reality and reflected illusion. By the time of the Water Lilies series, they are fused.

When Monet resumed work on paintings of his water garden, he observed it from a radically different vantage point. The purchase of additional land for the garden area, and excavations undertaken in 1901 enlarging the reflecting surface of the pond itself, perhaps stimulated Monet to focus on the water and to eliminate most indications of the surrounding garden. Without the traditional reference of a horizon line, only the water's surface remains, mirroring the garden along its banks and the clouds above, and supporting floating water lilies. Loose, abbreviated brushstrokes densely cover and emphasize the two-dimensional surface in lush layers of blue, green, and violet, accented with cream, magenta, and yellow, simultaneously evoking plants and reflections suspended on a liquid whose depth one can only guess.

Monet continued to explore the possibilities of his water garden for the rest of his life. Although the paintings in this series are increasingly abstract until the late images dissolve in light and color, forms are still recognizable in the work of 1907; only the water lilies themselves are less defined than in the 1905 version. In the larger later works, Monet expressed his increased freedom of vision with a corresponding freedom of brushwork. He described to Roger Marx in 1909 his intention to "capture better the life of atmosphere and light, which is the very life of painting, in its changing and fugitive play. Then, what does the subject matter! One instant, one aspect of nature contains it all." The wonder is that, despite the fact that Monet repainted the series in the studio, the pictures retain an impression of fluctuation and spontaneity. In these apparently timeless and intangible images, Monet joined his concern for light, reflection, and color with his passion for flowers and water.
L.H.G.

Monet made much use of the stabbing technique of application. The roughened paint helps to scatter the light falling on the picture surface, giving it a shimmer equivalent to that of light falling on actual water and flowers. Within these passages of rough paint there are areas where the surface was smoothed out when the paint was still wet or by a later application of another tone.

The water lilies along the bottom edge are painted with individual strokes to form each petal, and given more form by cool shadows. As the clumps of lilies recede into the distance the defining shapes become more blurred and uniform in color. The shadows cast by the lily pads fade away finally in the blue and green reflections of the trees.

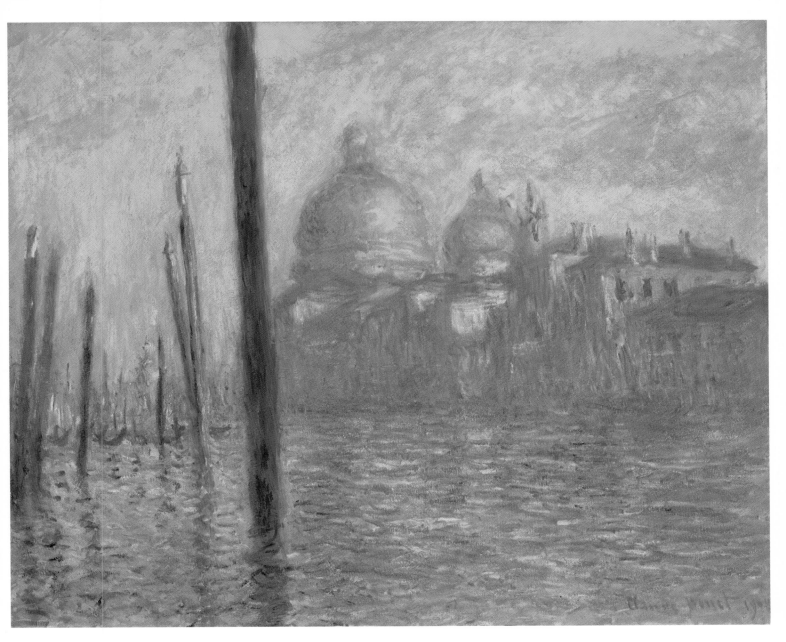

39
Grand Canal, Venice
Signed and dated 1908
Oil on canvas
28¾ x 36¼ in. (73 x 92 cm.)
Bequest of Alexander Cochrane
19.171

Seeing Venice for the first time in 1908, Monet was overcome by its beauty and wished that he had visited when he was younger and "still full of daring." But for a painter to be preoccupied with light rather than with the picturesque aspects of the city was daring enough. In this work the landmarks of Santa Maria della Salute and adjoining palazzi are recognizable and it is possible to imagine Monet's vantage point, yet the buildings are an insubstantial part of the whole, rising like a mirage from the Grand Canal. Defined only vaguely with fluid sketchy strokes and an even tonality of lavenders, blues, oranges, and pinks, their structure emerges through the juxtaposition of color from reflected light on their surfaces. Form is eroded by a luminous atmosphere. That Monet's principal concern was light is evidenced by the fact that he used the motifs again and again, in other versions virtually unchanged.

An invitation for Monet to visit Venice came late in his life. His initial visit, extending from September to December 1908, succeeded in easing his doubts about the water lily paintings and in improving his health. After returning the following year, he planned to come back in 1910 as

well, but his wife's illness prevented another trip, and the Venice paintings were subjected to reworking in his studio until twenty-nine were exhibited in 1912.

Monet was only one of many artists attracted to Venice during its nineteenth-century rediscovery. He was aware of Turner's work and the Venetian paintings by his fellow Impressionists Manet and Renoir. Although Monet's renderings are far more painterly, it is Whistler's Nocturnes of 1879 and 1880 that seem to prefigure Monet's impressions of the colors and atmosphere of Venice.
L.H.G.